Contents

KU-576-938

This, I hope you like.

Happy Birthday.

This is time when I have a lot to say,
and so little time
when I can talk.
And I can't see what the future will bring.

With so much love,
Caroline.

Cézanne

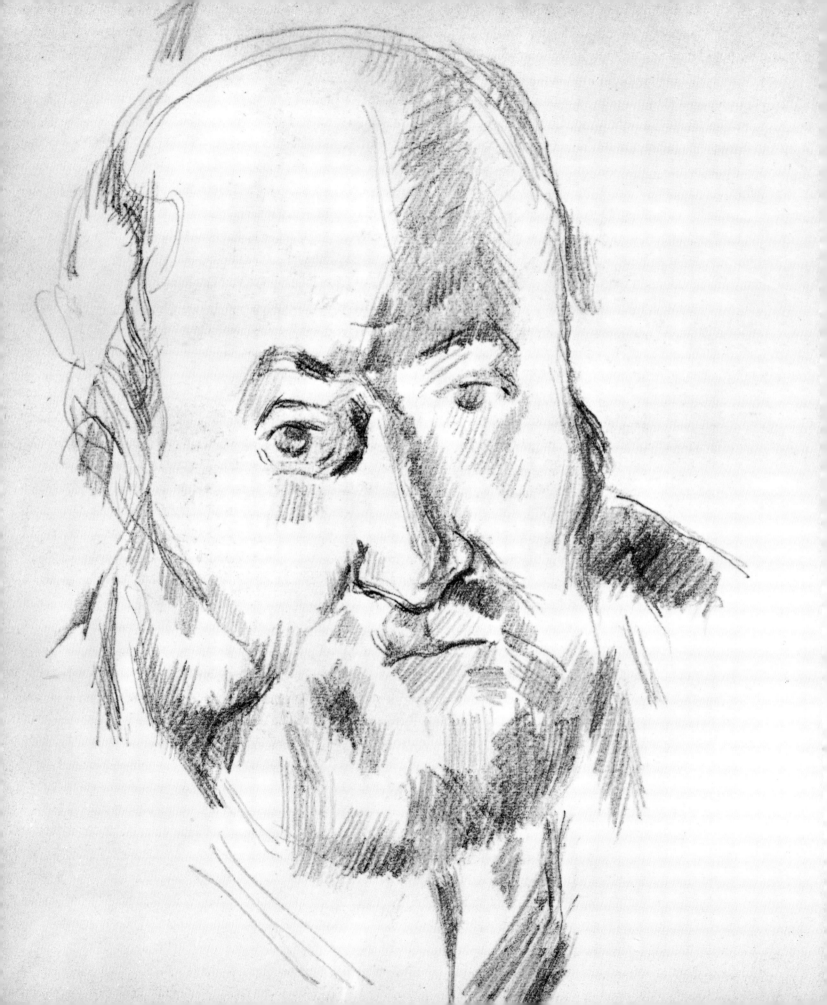

Basil Taylor

Cézanne

The Colour Library of Art

Hamlyn

London · New York · Sydney · Toronto

Acknowledgments

The works in this volume are reproduced by kind permission of the following collections, galleries and museums to which they belong: Art Institute of Chicago: Mr and Mrs Lewis L. Coburn Memorial Collection (Plate 7); Art Institute of Chicago: Gift of Annie Swan Coburn to the Mr and Mrs Lewis L. Coburn Memorial Collection (Plate 36); Art Institute of Chicago: Arthur Heun Fund (Figure 1); E.G. Bührle Collection, Zurich (Plates 3, 14, 35); Courtauld Institute Galleries, London (Plates 23, 26, 30, 32, 34, 38, 41); Solomon R. Guggenheim Museum, New York (Plate 40); Kunsthaus, Zurich (Plate 12); Kunstmuseum, Basel: Department of Prints and Drawings (Figures 2, 3, 4, 5); Lehman Collection, New York (Plate 25); Musée du Louvre, Paris (Plates 1, 5, 6, 8, 15, 16, 19, 20, 21, 24, 29, 37, 44); Musée du Louvre: Salles de l'Orangerie (Plate 10); Musée du Petit Palais, Paris (Plate 43); Museu de Arte, São Paulo (Plates 17, 31); Trustees of the National Gallery, London (Plates 27, 42, 47); National Gallery, Prague (Plates 22, 39); Philadelphia Museum of Art, Pennsylvania: George W. Elkins Collection (Plate 46); Philadelphia Museum of Art, Pennsylvania: W.P. Wilstach Collection (Plate 45); Private Collection, Paris (Plate 4); Private Collections, Switzerland (Plates 2, 18); Lord Rothschild Collection, Cambridge (Plates 9, 28); Trustees of the Tate Gallery, London (Plates 11, 34, 48, Figure 5); Siegfried Rosengart Collection, Lucerne (Plate 13). The following photographs were supplied by Brompton Studios, London (Plates 33, 48); Walter Drayer, Zurich (Plates 2, 12, 14); Giraudon, Paris (Plates 4, 5, 15, 18, 25, 43); Hans Hinz, Basel (Plate 35); Michael Holford, London (Plates 23, 32, 42); Raymond Laniepce, Paris (Plate 19); Horst Merkel, São Paulo (Plates 17, 31); Scala, Florence (Plates 10, 16, 20, 24); Fred Wirz, Lucerne (Plate 13); Alfred Wyatt, Philadelphia (Plates 45, 46); André Held-Joseph P. Ziolo, Paris (Plate 6).

Frontispiece: Self-portrait from sketchbook. 1886. Pencil. 5 × 8¾ in. (12.7 × 22.3 cm.). Art Institute of Chicago, Arthur Hein Fund.

Published by
THE HAMLYN PUBLISHING GROUP LIMITED
London · New York · Sydney · Toronto
Hamlyn House, Feltham, Middlesex, England

© copyright Paul Hamlyn Limited 1961
All plates © copyright S.P.A.D.E.M., Paris 1968
Revised edition 1968
Paperback edition 1970
Reprinted 1971

ISBN 0 600 03746 0

Printed in Italy by Officine Grafiche Arnoldo Mondadori, Verona

Introduction

CÉZANNE has been the patron-hero of painting for at least the first forty years of our century, and while his works have had the same kind of status in the history of art as Masaccio's frescoes in the Brancacci Chapel or the Sistine ceiling, it is perhaps the power of his presence and the virility of his ideals, more than the example of any single picture, which has inspired even artists whose intention and practice have been quite different from his own. Although his influence was to be posthumous and in spite of his personal detachment for so many years from the life of his time, he belonged intimately to the revolutionary current in nineteenth-century art.

Except for a few pictures of allegorical or imaginative subjects made in his twenties, he based his art upon the commonest features of ordinary life, or the elemental themes of European painting, the human head and figure, the nude, fruit, flowers, household properties and landscape, above all the Provençal landscape, which was not to be considered picturesque until he had transformed its harsh features into a series of glowing modern icons and joined it to the Campagna or the flat waterways of Holland as one of the fundamental landscapes of art. In the last thirty-five years of his life his painting was founded upon a direct visual perception of things; he would have agreed with Courbet that 'the art of painting can only consist of the representation of objects visible and tangible to the painter'. And at the heart of his exceptional integrity was a purity of perception which, although it resulted in works of an unprecedented character, showed nevertheless the typical Romantic sincerity of the nineteenth century, of a Constable, for example, or a Corot or a Monet.

At this time when a devotion to the analysis of colour perception and of the relationship between light and colour was as dominant as the study of space and proportion had been in fifteenth-century Italy, he attempted to create a new chromatic art in which the natural colour of the visible world in all its radiance, of apples or trees or sky, was to be brought into harmony with the ideal colour of a pictorial design determined by the necessities of structural firmness and order. His mature paintings were to have an unexampled intensity, every touch of pigment upon their surface not only being informed by his intense visual experience but contributing directly to the vitality and coherence of the whole work.

If many non-figurative painters in the 1960s would regard as old-fashioned such planned and premeditated works, organisms growing gradually by sketch, trial and constant deliberation towards completeness, they would at least respect Cézanne's devotion to the significance of the individual brush stroke as being the essential constituent of his art, not just the artist's own property, in a special sense, but the very embodiment of his understanding and sensations.

But if the formal and physical characteristics of his painting are in these ways so characteristic of the most radical ideas of his time and so significant for the period to follow, it has been the uncompromising nature of his personality and the conduct of his creative life which has given him a unique status. He was the most remarkable example in his age of a self-made painter, one not presented with facility and technical confidence from the beginning, like a Millais or a Meissonier, but a man who had painfully to uncover his talent and find the means to give shape to his ideals. With a Cartesian rigour, motivated by humility rather than scepticism, he had to fight his way back to the very elements of visual sensation and pictorial method.

His life shows an obstinate and fierce passion working within an unromantic, bourgeois shell. With his lifelong struggle with the realities of nature went an enduring sense of contest with society and its grappling conventions and opinions. A dogged modesty about his powers and the progress of his painting was mingled with a proud awareness of his own self-sufficiency. Nothing but the secure and eternal values of art could be taken for granted; every step had to be tested by personal experience and in action upon the canvas. And from this ideal emerged another aspect of his sincerity, a patience and slowness which is the quality distinguishing his work most obviously from the excited improvisations of our own time. As a man of impulsive behaviour, he reserved all that patience which could not be spared for his domestic and social life for the understanding of his sensations and the unfolding of his art. When he punished a canvas with a brush or a knife or threw it out of the window, that was because his powers had, in his view, failed or deserted him.

To these qualities must be added his attitude to material success and fame. Gauguin's ruthless withdrawal from modern civilisation, or the wordly failure of Van Gogh and the de-

struction of his physical and mental being, have seemed more arresting to the public, but they have never aroused the sympathy and respect of artists so strongly as Cézanne's less dramatic combat with art and nature.

Paul Cézanne was born at Aix-en-Provence in January 1839, his family having settled there in the early part of the eighteenth century. When he was nine his father, Louis-Auguste, who had made his living until then by dealing in hats, bought the only bank in the city, a transaction which was to bring him a considerable fortune. Cézanne's ancestry and the character of his family and home, their place in the local community, the circle of his friendships, all these have an unusually important role not only in the formation of his personality but in the detailed moulding of his creative intentions and behaviour. His fierce and often brutal independence and his passionate impulsiveness were not only typical of the temperament of a region where his family lad lived for so many generations, but may also be explained by the unpopularity of his parents in the city, occasioned by his father's financial success. The bourgeois framework of his later life, which was to sustain him through the anxieties and pressures of his artistic pilgrimage, was that natural to a prosperous middle-class family.

His studies at school—and he was a capable, hard-working pupil winning prizes for mathematics and history, as well as Greek and Latin—prepared him for the stringent disciplines he was later to impose upon himself. His chief boyhood companion was Emile Zola who, in one form or another, has left the most detailed and suggestive account we have of the youth of any great artist. We learn through him of Cézanne's excitable, enthusiastic and saturnine temperament, his way of quickly rising into anger or falling into gloom, his intense appetite for life and for the experiences both of nature and art which he shared not only with Zola but with another companion, Baptistin Baille, later to become an engineer.

The engagement of the three boys with the landscape of the region seems to have been no less devoted than Wordsworth's enjoyment of the Lakes, and in Zola's prose we hear echoes of *The Prelude*. 'In the winter we adored the cold, the ground hardened by frost which rang gaily, and we went to eat omelettes in neighbouring villages... in the summer all our meetings took place at the river bank, for then we were pos-

sessed by the water.' They enjoyed an equally fervent feeling for literature and above all for the most Romantic and eloquent writers of their time, with Victor Hugo as the chief hero. Cézanne, particularly in the period which followed Zola's departure for Paris in 1858, himself poured forth a stream of verse in which high-sounding seriousness was mixed with fun and irony; he planned, at this time, to write a five-act drama to be called 'Henry VIII of England'.

The circumstances of his boyhood, then, provided him with an immensely valuable and deep-laid cache of experience without which he could not have sustained his subsequent career, for at this early age he became firmly anchored to art and to nature. He came to feel a certainty of such physical presences as Mont Sainte-Victoire or his father's substantial house, the Jas de Bouffan, upon which so much of his painting was to be founded. These were to be the strong securities upon which his unquiet, exploratory spirit could depend.

It was not until he was nearly twenty that Cézanne's determination to become a painter took possession of him. By 1860 he had persuaded his father to accept this as his vocation, and whatever may have been Zola's failure of sympathy and understanding in later years, at this time he was a provider of stout and positive encouragement. In April 1861, having studied for two years in the Free Drawing Academy at Aix, Cézanne arrived for the first time in Paris where he went to work at the Atelier Suisse. The following period of six months before his return to Provence and his father's office was a time of drab discouragement, but by the end of 1862, and after a phase of further indecision, he finally committed himself to painting and to a return to Paris.

The next ten years, shared between that city and Provence, were also the formative years of Impressionism, beginning with the famous Salon des Refusés of 1863 and culminating in the First Impressionist Exhibition of 1874. In this time Cézanne came to know the leading exponents of the new art, Manet and Pissarro in particular; he was associated with them in their trials and struggles and involved in the controversies and critical debates which attended their development, but it was not until the very end of this time that he was to follow their artistic direction. The transformation of his painting to one based upon Impressionism and a central use of colour, foreshadowed by a work such as *The Railway*

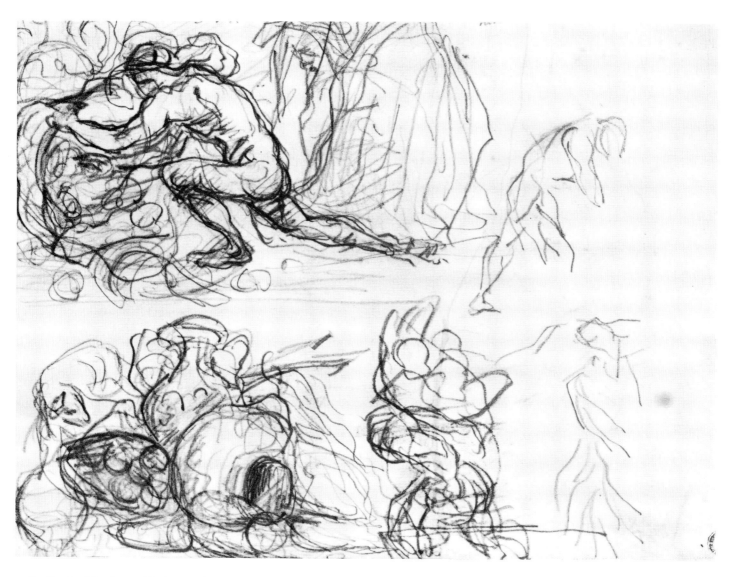

2. Studies for *The Orgy*. 1864-8. Pencil. 7 × 9 in. (17.7 × 23 cm.). Kunstmuseum, Basel.

Cutting of 1866 (now in Munich) was finally accomplished when he was staying with Camille Pissarro at Pontoise in 1872—73. The first masterpiece of the new phase was to be *The House of the Hanged Man* (plate 6).

He called his friend 'the humble and colossal Pissarro', and Lawrence Gowing has rightly suggested that only someone who was possessed of humility as well as profound artistic seriousness and authority could have influenced such a passionate and obstinately determined individual as Cézanne.

The period of his twenties, which was to end thus at Pontoise and Auvers, might paradoxically be described as the one in which his personality found its most direct artistic utterance. The dark, impulsive, poeticising youth, which we can see in Zola's portrait of the young Cézanne, found itself in the dark, wild, baroque and often melodramatic pictures of this time. At this period the spirit of his personality flamed nakedly as in a lamp; thereafter its energy was relatively concealed and drove a complex mechanism of objective exploration and pictorial thought. Thereafter the force of his passion was not translated directly into images but was the source of his artistic persistence, stamina and survival. The fact that many of these early pictures, like *The Black Clock* (plate 4), are so noble and possessive is not only that they are the first experiments of a great painter but because of their extreme concentration and vitality. Their fundamental darkness (for their source, as with the work of Rembrandt or Caravaggio, is shadow rather than light), their abrupt transitions of tone and their rich, corrugated pigment not only show an emergent artist's struggle to master his art but are the direct translation of his energy and introspection.

It is said that when Cézanne was working in these early years at the Atelier Suisse he found it impossible to draw direct from the living model, but had to construct the nude figure in the quiet of his studio, and this was probably a reflection not just of his anxiety in the face of a difficult natural form but of his emotional response to the presence of a living creature which had been the vehicle and focus of so much painting and poetry. There is a great similarity between the character of these early pictures and what Zola achieved in his fiction, a realism based upon observation of common life but composed and presented in terms of dramatic conventions which are something quite distinct from the plain current of events. Zola, however objective his intentions, never escaped from this kind of Romanticism, and that is perhaps the main reason why in every sense he was to lose touch with his friend.

The following thirty-five years brought Cézanne hardly any more critical or material success, for his work continued to be attacked and misunderstood by all but a few friends and perceptive sympathisers. Even his friends wrote or spoke of him, quite justly, as a man set apart, detached by the loneliness of his enquiries, so that Van Gogh, working only a few hours away from Cézanne's painting-ground, can write of him as if he belonged to another age and another continent. In an elusive way the structure of his artistic life had changed with the revelations of the 1870s. Hitherto, his way can be described as the painful ascent of a mountain ridge, the path circuitous and strewn with obstacles, but his progress supported by guides. From the moment he reached the top of that ascent he found stretched before him a flat and pathless wilderness with one conspicuous destination upon the distant horizon. The way was straighter but no less, if differently, arduous, and no companionship could assist him.

If we seek to understand the art of his maturity we must begin with that classic sentence which not only epitomises Cézanne's artistic philosophy but has been one of the founding sentences of modern taste and criticism: 'Art is a harmony, parallel with the harmony of nature.' He intended by the 'harmony of nature' not, I believe, anything as Platonic as an order of abstract forms underlying the appearance and material substance of nature. In another and equally influential dictum which begins, 'Treat nature by the cylinder, the sphere, the cone...' the word 'treat' is most significant, because he was surely thinking of these elemental volumes not as the explanation and source of natural objects but as a guide to the pictorial rendering of them. (He has said elsewhere that practice in the construction of these volumes should form the beginning of a painter's training.) He had, indeed, a more Goethean acceptance of the validity and truth of immediate perception, as is suggested by the words 'sensations form the foundation of my work'. But if the sensation of nature was the foundation, natural experience required to be set in order and put under rational restraint. 'All things, particularly in art, are theory developed and applied in contact

with nature.' And such was not a philosophy of nature but of the parallel world of art, a theory of pictorial design and formal relationships. 'Painting is not only to copy the object, it is to seize a harmony between numerous relations.'

As Cézanne wrote of the process of humanising a landscape through the exercise of an artist's feelings, so he clearly considered the power to create pictorial harmony as something not altogether rational. 'One can do good things without being much of a harmonist or colourist. It is sufficient to have a sense of art.' And that sense embraced, no doubt, what he called taste.

The demon with which he constantly struggled was the kaleidoscopic force which nature afforded through perception and which was enhanced by his passionate temperament. 'I cannot attain the intensity that is unfolded before my senses.' That confession is a sign both of his modesty and his sincere integrity. But it was impossible for him, in spite of deliberate withdrawal from social and artistic circles and his critical attitude towards the art of his time, to isolate himself either from the contemporary current of painting which had, in the 1870s, transformed his own practice, or from the ideological climate of his age. And so he proposed that 'our art should give to nature the thrill of continuance with the appearance of all changes'. This observation explains his stated wish to make of Impressionism something as enduring as the art of the museums, the one the modern embodiment of motion, flux and the instability of physical events, the other a witness to an eternal and stable monumentality. He had to admit the impossibility for him of bringing together a group of living models to enact a Poussin-like composition in open-air circumstances which would present to his eyes the actual, vibrant conditions of nature and of natural light, with its atmospheric restlessness.

'The whole of painting'—the whole problem of painting, that is—'is there, to yield to the atmosphere or to resist it. To yield is to deny local colours. To resist it is to give them force and variety. Titian and Veronese work by "localities" and that is what colourists do.' And so his art was to be essentially colouristic. 'Drawing and colour are not separate, everything in nature being coloured. The more the colour harmonises, the more the drawing becomes precise.' The structural coherence of solid forms, of an apple or a human head, depends upon a harmonised orchestration of colour, and without such coherence of form, drawing, which was for him the creation of volumes and not the definition of imaginary outlines, becomes slack and inexpressive. But colour is not only the means of forming volumes, but also, through its inherent tonality, the way of rendering space. 'I want to render perspective solely by means of colour.'

Such a comprehensive use of colour, which is by its nature the most dynamic, subtle and demanding of all the painter's tools, brought with it not only the struggles and anxieties which typify his career but those distinctive distortions which so troubled his contemporaries. 'The sensations of colour which give light are the reasons for the abstractions which prevent me either covering my canvas or continuing the delineation of objects when their points of contact are fine and delicate.' If his grappling with the intensity of his sensational impressions was one source of his creative agony, then an equally important one was the striving to resolve the complex equation of colour equals coloured volume plus light plus space which he had imposed upon himself. For he had set out to encompass not some general harmony but such a complex, concentrated and profoundly subtle unity that the slightest failure of observation, understanding or control could bring disaster. 'There must not be a single link too loose, not a crevice through which may escape the emotion, the light, the truth.'

This profound and terrifying ideal explains not only why, as he said, 'I advance all my canvas at one time together', but why his painting demanded the whole of his being acting together at a point of maximum concentration, why his life was so arduous, why his moments of despair were large and why so many of his pictures show the marks of struggle, correction of an ultimate surrender to a necessary incompleteness, features which only the wisest in his time, most of them fellow-painters, could regard as anything but a failure of skill or understanding or as a clumsy groping towards unworthy ends.

If these were the main artistic ideas and procedures which formed his painting, how do we experience the result of them in front of the pictures? Cézanne was accustomed, in talking about painting, to make a slight but eloquent gesture, here described by his friend Emile Bernard, in this way. 'I have

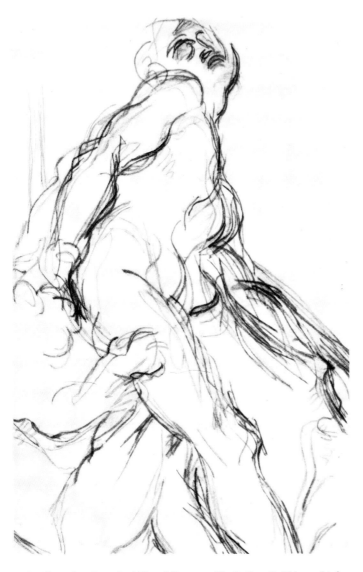

3. Studies after Puget's *Milo of Crotona*. 1883-8. Pencil. 8⅜ × 4¾ in. (21.1 × 12.1 cm.). Kunstmuseum, Basel.

my motif. (He joins his hands.) A motif, you see, is this. (He draws his hands apart, fingers spread out, and brings them together again, slowly; then joins them, presses them together and contracts them, making them interlace.) There you have it; that is what one must attain.' It is not too fanciful, I believe, to compare this action and the image it creates with the structure of a Gothic cathedral. Gothic has visually been the most dynamic form of architectural expression just because its structural components declare their presence, purpose and activity so explicitly. Vault, pier, aspiring arch

and flying buttress combine in an energetic contest of thrust and counter-thrust. Cézanne's art has often been called classical, but its harmony is dynamic. The *Bathers* (plate 46) is not a Roman, a Raphaelesque structure, but a Gothic one, for the absent meeting of the arching tree trunks will form not a rounded but a pointed arch. The passive calm of post and lintel does not belong to Cézanne's art.

Another source of his unique expressiveness is the radiance of his pictures. From edge to edge of the canvas they emit an intense chromatic glow reminiscent of Byzantine mosaics and, in European oil painting, not so much his favourite Venetians but such a late work of Rembrandt as the Brunswick family group. The sensationalist psychology of the nineteenth century explained man's visual perceptions in terms not of objects but of spots of colour which the mind orders into the form of our mental experience, and we find an echo of this in the following statement by Cézanne: 'I take from left and right, here, there, everywhere; tones, colours, shades, I fix them, I bring them together. They make lines. They become objects, rocks, trees, without my thinking about it. They take on volume. They acquire value. If these volumes, these values, correspond on my canvas, in my feeling, to the planes and patches of colour which are there before my eyes, very good. My canvas joins hands'.

In spite of its radiance, Cézanne's painting does not provide the brash brilliance of Expressionism or Fauvism, in which every colour seems to possess the same quality of brightness, but a subtly differentiated intensity which respects the particular dynamism of each colour. The components, the bricks, from which his pictures are built are, then, the coloured touches, and in his finest paintings they operate singly as tones in a melodic line and in consort, voicing one marvellously orchestrated statement of pictorial harmony, massive and spacious. The function of his *taches* was to become quite distinct from those of Impressionism, which, having to give up their separate vitality in the cause of a general luminosity, do not play so forcefully upon our sensations. In the Cézannes of the 1870s, such as the *Portrait of Victor Chocquet* (plate 9), the coloured touches are so physically substantial that they suggest the density of the subject, while their varying direction is used not only to enhance the modelling but to indicate the inclination of the planes. Later, and particularly after the

mid-nineties, the strokes of the brush generally became less descriptive, and the pattern of their almost vertical movement makes the objects emerge in exactly the way Cézanne describes in the passage quoted above.

The one element in the objective world with which Cézanne was hardly concerned was texture and the quality of surface. His *taches* do not explain the nature of anything's skin, but they do differentiate between the special qualities of different masses, the difference in this respect between an apple and a ginger jar.

After its splendid chromatic character the most typical feature of Cézanne's art lies in his treatment of space. As might be expected in a man whose chief tool is colour, the pictures are not governed by the laws of central perspective or controlled by a single vanishing point. The eye is directed into the structure of the subject along various lines of advance, and if we associate our visual experience of the pictures with what we know of Cézanne's procedure we may appreciate his intentions. We must think of him subjecting every part of every subject to the most intense and specific scrutiny, so that every section acquires an identical significance. Each element in the picture comes to have its own spatial location and environment connected by colour with all the other elements in his design. As his paintings are constructions in terms of colour, in which every object is allowed to express itself with the same intensity, they are relatively shallow in depth, the sky being as substantial as a rock, or the earth.

What disturbed Cézanne's critical contemporaries most and raised the scorn of his enemies were those deformities and distortions of form which seemed arbitrary and unintelligent— the lop-sided jars and bottles, those precariously slanting planes, those inequalities between one part of an object and another. Something of this is to be explained by the concept of spatial projection mentioned above, but it also arose from his acute and fastidious sense of pictorial unity which constantly demanded these modifications as the very condition of organic unity within the work.

Cézanne has declared his essential artistic intentions as clearly as any painter, and the sensations we receive in front of his work are powerful and explicit. What remains, and probably always will remain, elusive is the exact nature of his methods, which are the cause of constant debate and dis-

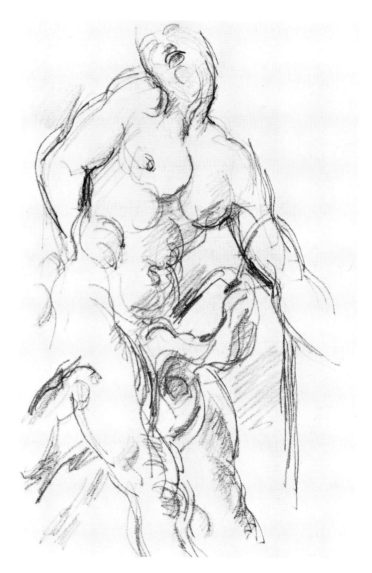

4. Studies after Puget's *Milo of Crotona*. 1883-8. Pencil. 8⅜ × 4¾ in. (21.1 × 12.1 cm.). Kunstmuseum, Basel.

agreement. But we, fifty-five years after his death, are better placed to understand how comprehensive an artist he was, than those who immediately followed him and who, as artists or critics, used his art to defend their own concepts. He is not to be explained or appreciated in terms simply of significant form, but only by recognising the presence of those three elements which he struggled so hard to unite, nature, art and that inner personal life of sensation and feeling which knew the whole gamut of experience, from joy to despair.

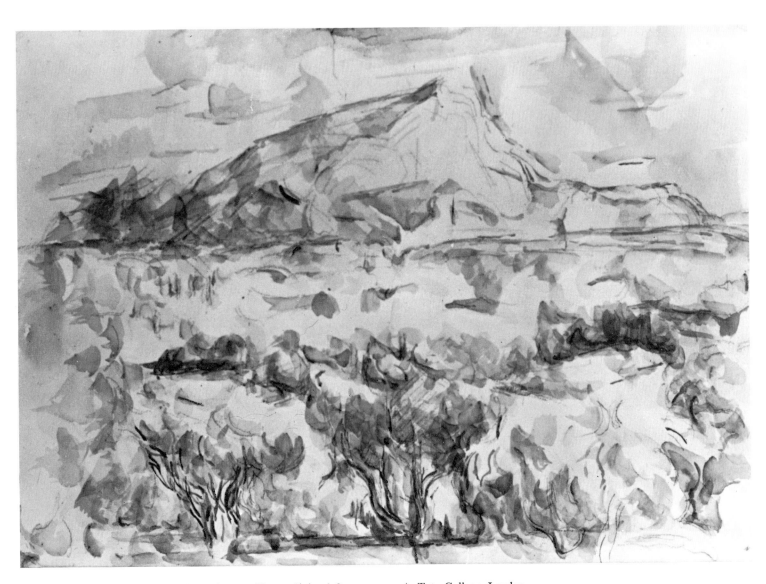

5. Mont Ste-Victoire. *c.* 1904-6. Watercolour. 14⅝ × 21⅝ in. (36.2 × 54.9 cm.). Tate Gallery, London.

Extracts from the letters of Cézanne

I am beginning to consider myself stronger than all those around me, and you know that the good opinion I have of myself has only been reached after mature consideration. I have still got to work, not so as to be able to add the final polish, that is for the admiration of imbeciles. And the thing that is commonly so much appreciated is merely the reality of the handwork and renders all work resulting from it inartistic and common. I must strive after perfection only for the pleasure of giving added truth and learning. And believe me, the hour always comes when one makes an impression and one has admirers far more fervent and convinced than those who are only flattered by the empty appearances.

To the artist's mother, 26th September, 1874.

Monsieur Chocquet who spoke to me about them... It is like a playing card—red roofs over the blue sea. If the weather is favourable I may perhaps carry them through to the end. Up to the present I have done nothing.—But motifs could be found which would require three or four months' work, for the vegetation does not change here. The olive and pine tree are the ones which always preserve their foliage. The sun is so terrific here that it seems to me as if the objects were silhouetted not only in black and white, but in blue, red, brown and violet. I may be mistaken, but this seems to me to be the opposite of modelling.

To Camille Pissarro, 2nd July, 1876.

I should have wished to possess the intellectual equilibrium that characterises you and permits you to achieve without fail the desired end... Chance has not favoured me with an equal self-assurance, it is the only regret I have about things of this earth. With regard to the rest I have nothing to complain of. Always it is the sky, the things without limits that attract me and give me the opportunity of looking at them with pleasure

But as regards the realisation of the most simple wishes, which seem as if they should proceed by themselves, a luckless fate is apparently present to impair success; I had a few vineyards but unseasonable frost came and cut the thread of my hopes. Whereas my wish on the contrary was for them to flower, and so I can only wish that your plantations shall flourish and your vegetation develop well: green being one of

the gayest colours which is the most soothing to the eyes. To conclude I must tell you that I still go on with my painting and that this country here, which has never found an interpreter worthy of the richness it harbours, contains many treasures to be gathered.

To Victor Chocquet, 11th May, 1886.

... the many studies I made having given only negative results, I had resolved to work in silence until the day when I should feel myself able to defend in theory the results of my attempts.

To Octave Maus, 27th November, 1889.

If I am not mistaken you appeared to be very angry with me. Could you but see inside me, the man within, you would be so no longer. Do you not see to what a sad state I am reduced? Not master of myself, a man who does not exist, and it is you, who claim to be a philosopher, who would cause my final downfall? But I curse the X...s and the few rascals who, for the sake of writing an article for fifty francs, drew the attention of the public to me. All my life I have worked to be able to earn my living, but I thought that one could do good painting without attracting attention to one's private life. To be sure an artist wishes to raise his standard intellectually as much as possible, but the man must remain in obscurity. Pleasure must be found in the studying. If it had been given to me to succeed, I should have remained in my corner with my few studio companions with whom we used to go out for a pint... You are young, and I can understand that you wish to succeed. But for me, what is there left for me to do in my position but submit? And were it not that I am passionately fond of the contours of this country, I should not be here.

To Joachim Gasquet, 30th April, 1896.

Monsieur,
The rather discourteous manner with which you take the liberty of entering my room is not calculated to please me. In the future please see that you are announced.

Please give the glass and the canvas which were left in your studio to the person who comes for them.

To Louis Le Bail, 1898.

It seems to me that I find it difficult to dissociate myself from

the young people who have shown themselves to be so much in sympathy with me, and I do not think that I shall in any way harm the course of my studies by exhibiting.

To Ambroise Vollard, 17th March, 1902.

I have made some progress. Why so late and with such difficulty? Is art really a priesthood that demands the pure in heart who must belong to it entirely?

To Ambroise Vollard, 9th January, 1903.

In your letter you speak of my realisation in art. I think that every day I am attaining it more, although with some difficulty. For if the strong experience of nature—and assuredly I have it—is the necessary basis for all conception of art on which rests the grandeur and beauty of all future work, the knowledge of the means of expressing our emotion is no less essential, and is only to be acquired through very long experience... The approbation of others is a stimulus of which, however, one must sometimes be wary. The feeling of one's own strength renders one modest.

To Louis Aurenche, 25th January, 1904.

May I repeat what I told you here: treat nature by the cylinder, the sphere, the cone, everything in proper perspective so that each side of an object or a plane is directed towards a central point. Lines parallel to the horizon give breadth, that is a section of nature, or if you prefer, of the spectacle that the *Pater Omnipotens Aeterne Deus* spreads out before our eyes. Lines perpendicular to this horizon give depth. But nature for us men is more depth than surface, whence the need of introducing into our light vibrations, represented by reds and yellows, a sufficient amount of blue to give the impression of air.

To Emile Bernard, 15th April, 1904.

I am progressing very slowly, for nature reveals herself to me in very complex forms; and the progress needed is incessant. One must see one's model correctly and experience it in the right way; and furthermore express oneself forcibly and with distinction.

Taste is the best judge. It is rare. Art only addresses itself to an excessively small number of individuals.

The artist must scorn all judgement that is not based on an intelligent observation of character. He must beware of the literary spirit which so often causes painting to deviate from its true path—the concrete study of nature—to lose itself all too long in intangible speculations.

The Louvre is a good book to consult, but it must only be an intermediary. The real and immense study that must be taken up is the manifold picture of nature.

To Emile Bernard, 12th May, 1904.

Painters must devote themselves entirely to the study of nature and try to produce pictures which are an instruction. Talks on art are almost useless. The work which goes to bring progress in one's own subject is sufficient compensation for the incomprehension of imbeciles.

Literature expresses itself by abstractions, whereas painting, by means of drawing and colour, gives concrete shape to sensations and perceptions. One is neither too scrupulous nor too sincere nor too submissive to nature; but one is more or less master of one's model, and, above all, of the means of expression. Get to the heart of what is before you and continue to express yourself as logically as possible.

To Emile Bernard, 26th May, 1904.

To achieve progress nature alone counts, and the eye is trained through contact with her. It becomes concentric by looking and working. I mean to say that in an orange, an apple, a bowl, a head, there is a culminating point; and this point is always—in spite of the tremendous effect of light and shade and colourful sensations—the closest to our eye; the edges of the objects recede to a centre on our horizon. With a small temperament one can be very much of a painter. One can do good things without being very much of a harmonist or a colourist. It is sufficient to have a sense of art—and this sense is doubtless the horror of the bourgeois. Therefore, institutions, pensions, honours, can only be made for cretins, rogues and rascals. Do not be an art critic, but paint, therein lies salvation.

To Emile Bernard, 25th July, 1904.

Studying the model and realising it is sometimes very slow in coming for the artist.

Whoever the master is whom you prefer, this must only be

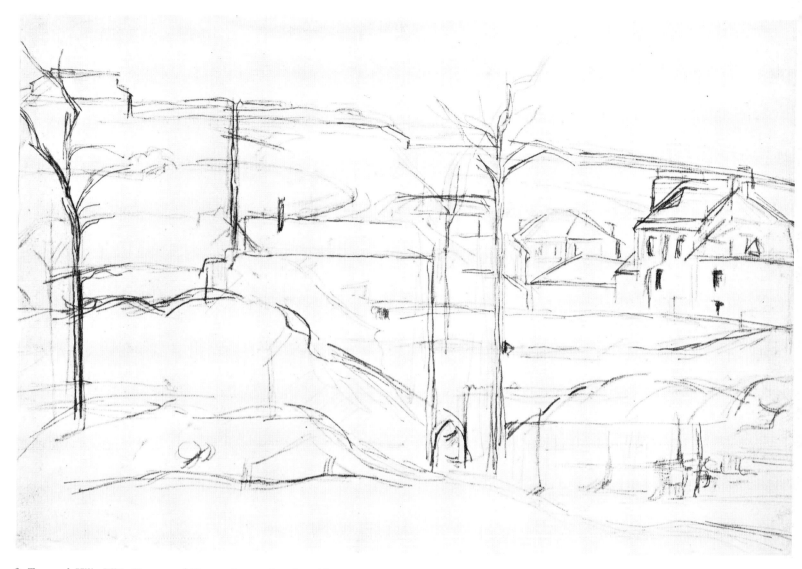

6. Terraced Hills With Houses and Trees. 1870-74. Pencil. 12⅜ × 18⅝ in. (31.3 × 47.3 cm.). Kunstmuseum, Basel.

a directive for you. Otherwise you will never be anything but an imitator. With any feeling for nature whatever, and some fortunate gifts—and you have some—you should be able to dissociate yourself; advice, the methods of another, must not make you change your own manner of feeling. Should you at the moment be under the influence of one who is older than you, believe me, as soon as you begin to feel yourself, your own emotions will finally emerge and conquer their place in the sun—*get the upper hand*, confidence—what you must strive to attain is a good method of *construction*...

Michelangelo is a constructor, and Rafael an *artist* who, great as he is, is always limited by the model. When he tries to be thoughtful he falls below the *niveau* of his great rival.

To Charles Camoin, 9th December, 1904.

Yes, I approve of your admiration for the strongest of all the Venetians; we are celebrating Tintoretto. Your desire to find a moral, an intellectual point of support in the works, which assuredly we shall never surpass, makes you continually on the *qui vive*, searching incessantly for the way that you dimly apprehend, which will lead you surely to the recognition in front of nature, of what your means of expression are; and the day you will have found them, be convinced that you will find also, without effort and in front of nature, the means employed by the four or five great ones of Venice.

This is true without possible doubt—I am very positive: —an optical impression is produced on our organs of sight which makes us classify as light, half-tone or quartertone, the surfaces represented by colour sensations. (So that light does not exist for the painter.) As long as we are forced to proceed from black to white, the first of these abstractions being like a point of support for the eye as much as for the mind, we are confused, we do not succeed in mastering ourselves, in possessing ourselves.

To Emile Bernard, 23rd December, 1904.

My age and my health will never allow me to realise the dream of art that I have been pursuing all my life. But I shall always be grateful to the public of intelligent amateurs who had—despite my own hesitations—the intuition of what I wanted to attempt for the renewal of my art. To my mind one should not substitute oneself for the past, one has merely to add a new link. With the temperament of a painter and an ideal of art, that is to say, a conception of nature, sufficient powers of expression would have been necessary to be intelligible for man and to occupy a suitable position in the history of art.

To Roger Marx, 23rd January, 1905.

As you write, I think I really have made some slight progress in the last studies that you saw at my house. It is, however, very painful to have to register that the improvement produced in the comprehension of nature from the point of view of the form of the picture and the development of the means of expression should be accompanied by old age and a weakening of the body.

The Louvre is the book in which we learn to read. We must not, however, be satisfied with retaining the beautiful formulas of our illustrious predecessors. Let us go forth to study beautiful nature, let us try to free our minds from them, let us strive to express ourselves according to our personal temperaments. Time and reflection, moreover, modify, little by little, our vision, and at last comprehension comes to us.

To Emile Bernard, 1905.

Now, being old, nearly 70 years, the sensations of colour, which give light, are the reason for the abstractions which prevent me from either covering my canvas or continuing the delimitation of the objects when their points of contact are fine and delicate; from which it results that my image or picture is incomplete. On the other hand, the planes are placed one on top of the other from whence neo-impressionism emerged, which outlines the contours with a black stroke, a failing that must be fought at all costs. Well, nature, when consulted, gives us the means of attaining this end.

To Emile Bernard, 23rd October, 1905.

Finally I must tell you that as a painter I am becoming more clear-sighted in front of nature, but that with me the realisation is always very difficult. I cannot attain the intensity that is unfolded before my senses. I have not the magnificent richness of colouring that animates nature. Here on the edge of the river, the motifs are very plentiful, the same subject seen from a different angle gives a subject for study of the highest interest and so varied that I think I could be occupied for months without changing my place, simply bending a little more to the right or left.

To his son, 8th September, 1906.

From *Paul Cézanne Letters*, edited by John Rewald, translated from the French by Marguerite Kay, Cassirer, Oxford 1946

Cézanne as seen by his contemporaries

Monsieur Cézanne is from Provence and is like the man from the Midi whom Daudet describes: 'When first I saw him I thought he looked like a cut-throat with large red eyeballs standing out from his head in a most ferocious manner, a rather fierce-looking pointed beard, quite grey, and an excited way of talking that positively made the dishes rattle'. I found later on that I had misjudged his appearance, for far from being fierce or cut-throat, he has the gentlest manner possible, 'comme un enfant', as he would say. His manners at first rather startled me—he scrapes his soup plate, then lifts it and pours the remaining drops in his spoon; he even takes his chop in his fingers and pulls the meat from the bone. He eats with his knife and accompanies every gesture, every movement of his hand, with that implement, which he grasps firmly when he commences his meal and never puts down until he leaves the table. Yet in spite of the total disregard of the dictionary of manners, he shows a politeness towards us which no other man here would have shown. He will not allow Louise to serve him before us in the usual order of succession at the table; he is even deferential to that stupid maid, and he pulls off the old tam-o-shanter, which he wears to protect his bald head, when he enters the room...

Cézanne is one of the most liberal artists I have ever seen. He prefaces every remark with: 'Pour moi' it is so and so, but he grants that everyone may be as honest and as true to nature from their convictions; he doesn't believe that everyone should see alike.

Mary Cassatt (from a letter dated 1894)

At Vollard's there is a very complete exhibition of Cézanne's works. Still-lifes of astonishing perfection, and some unfinished works really extraordinary for their fierceness and character. I don't imagine they will be understood...
I also thought of Cézanne's show in which there were exquisite things, still-lifes of irreproachable perfection, others *much worked on* and yet unfinished, of even greater beauty, landscapes, nudes and heads that are unfinished but yet grandiose, and so *painted*, so supple... Why? Sensation is there!...
Curiously enough, while I was admiring this strange disconcerting aspect of Cézanne, familiar to me for many years, Renoir arrived. But my enthusiasm was nothing compared with Renoir's. Degas himself is seduced by the charm of this refined savage, Monet, all of us... Are we mistaken? I don't think so. The only ones who are not subject to the charm of Cézanne are precisely those artists or collectors who have shown by their errors that their sensibilities are defective. They properly point out the faults we all see, which leap to the eye, but the charm—that they do not see. As Renoir said so well, these paintings have I do not know what quality; like the things of Pompeii, so crude and so admirable!...

Camille Pissarro: *Letters to Lucien*

Ripe grapes overflow the edges of a shallow dish; on the cloth bright green and violet-red apples are mingled. The whites are blue and the blues are white. A devil of a painter, his Cézanne!

Cézanne paints a brilliant landscape: ultramarine background, heavy greens, glistening ochres: a row of trees, their branches interlaced, allowing, however, a glimpse of the house of his friend Zola, with its vermilion shutters turned orange by the yellow reflected from the walls. The burst of emerald greens expresses the delicate verdure of the garden, while in contrast the deep note of the purple nettles in the foreground orchestrates the simple poem. It is at Médan.

A pretentious passer-by takes an astonished glance at what he thinks is some amateur's pitiful mess and, smiling like a professor, says to Cézanne: 'You paint?'
'Certainly, but not very much.'
'Oh, I can see that. Look here, I'm an old pupil of Corot's and if you'll allow me, I can put that in its proper place for you with a few skillful touches. Values, values... that's the whole thing!'
And the vandal impudently spreads his imbecilities over the brilliant canvas. Dirty greys cover the Oriental silks.
'How happy you must be, Monsieur!' cries Cézanne. 'When you do a portrait I have no doubt you put the shine on the end of the nose as you do on the legs of the chair.'
Cézanne seizes his palette, and with his knife scrapes off all Monsieur's dirty mud. Then, after a moment of silence,

he lets a tremendous... and turning to Monsieur, says, 'Oh! what a relief.'

<div style="text-align:right">Paul Gauguin: Intimate Journals, translated by Van Wyck Brooks, Heinemann, London, 1930</div>

Instinctively these days I keep remembering what I have seen of Cézanne's, because he has rendered so forcibly—as in the 'Harvest' we saw at Portier's—the harsh side of Provence. It has become very different from what it was in spring... I'm thinking of what Portier used to say, that seen by themselves, the Cézannes he had didn't look like anything else, but put near other pictures, they washed the colour out of everything else. He also used to say that the Cézannes did well in gold, which means that the colour scheme was pitched very high...

The country near Aix, where Cézanne works, is just the same as this, it is still the Crau. If coming home with my canvas, I say to myself, 'Look! I've got the very tones of old Cézanne!' I only mean that Cézanne, like Zola, is so absolutely part of the countryside and knows it so intimately, that you must make the same calculations in your head to arrive at the same tones. Of course, if you saw them side by side, mine would hold their own, but there would be no resemblance...

I think that the continual wind here must have something to do with the haggard look the painted studies have. Because you see it in Cézanne too...

If you saw my canvases, what would you say of them? You won't find the almost timid, conscientious brush stroke of Cézanne in them. But as I am now painting the same landscape, Crau and Camargue—though at a slightly different spot—there may well remain certain connections in it in the matter of colour. I couldn't help thinking of Cézanne from time to time, at exactly those moments when I realised how clumsy his touch in certain studies is—excuse the word clumsy—seeing that he probably did these studies when the mistral was blowing. As half the time I am faced with the same difficulties, I get an idea of why Cézanne's touch is sometimes so sure, whereas at other times it appears awkward. It's his easel that's reeling...

Cézanne is a respectable married man, just like the old Dutchmen; if there is plenty of male potency in his work, it is because he does not let it evaporate in merry-making.

<div style="text-align:right">Vincent van Gogh: Letters to Theo</div>

Later comments on Cézanne

It would be untrue to say that he had no talent, but whereas the intention of Manet and of Monet and of Degas was always to paint, the intention of Cézanne was, I am afraid, never very clear to himself. His work may be described as the anarchy of painting, as art in delirium. It is impossible to deny to this strange being a certain uncouth individuality, otherwise no one would remember him. I pause to ask myself which I would prefer, one of Millet's conventional, simpering peasants or one of Cézanne's crazy cornfields, peopled with violent reapers, reapers from bedlam. I think that I prefer Cézanne.

George Moore: *Reminiscences of the Impressionist Painters*, Maunsel, Dublin, 1906

One has the impression that each of these objects is infallibly in its place, and that its place was ordained for it from the beginning of all things, so majestically and serenely does it repose there. Such phrases are, of course, rather fantastic, but one has to make use of figurative expressions to render at all the extraordinary feeling of gravity and solemnity which the artist has found how to evoke from the presentment of these commonplace objects. One suspects a strange complicity between these objects, as though they insinuated mysterious meanings by the way they are extended on the plane of the table and occupy the imagined picture space. Each form seems to have a surprising amplitude, to permit of our apprehending it with an ease which surprises us, and yet they admit a free circulation in the surrounding space. It is above all the main directions given by the rectilinear lines of the napkin and the knife that make us feel so vividly this horizontal extension. And this horizontal supports the spherical volumes, which enforce, far more than real apples could, the sense of their density and mass...

We may describe the process by which such a picture is arrived at in some such way as this: the actual objects presented to the artist's vision are first deprived of all those specific characters by which we ordinarily apprehend their concrete existence—they are reduced to pure elements of space and volume. In this abstract world these elements are perfectly co-ordinated and organized by the artist's sensual intelligence, they attain logical consistency. These abstractions are then brought back into the concrete world of real things, not by giving them back their specific peculiarities but by expressing them in an incessantly varying and shifting texture. They retain their abstract intelligibility, their amenity to the human mind, and regain that reality of actual things which is absent from all abstractions.

Of course in laying all this out one is falsifying the actual processes of the artist's mind. In reality, the processes go on simultaneously and unconsciously—indeed the unconsciousness is essential to the nervous vitality of the texture. No doubt all great art arrives at some such solution of the apparently insoluble problems of artistic creation. Here in certain works of Cézanne we seem to get a particularly clear vision of the process of such creations...

Of all Cézanne's portraits perhaps that of M. Geffroy is the most celebrated... The equilibrium so consummately achieved results from the counterpoise of a great number of directions. One has only to imagine what would happen if the books on the shelf behind the sitter's head were upright, like the others, to realize upon what delicate, adjustments the solidity of this amazing structure depends. One cannot think of many designs where so complex a balance is so securely held. The mind of the spectator is held in a kind of thrilled suspense by the unsuspected correspondences of all these related elements. One is filled with wonder at an imagination capable of holding in so firm a grasp all these disparate objects, this criss-cross of plastic movements and directions. Perhaps, however, in order to avoid exaggeration, one ought to admit that since Cézanne's day other constructions have been made as complex and as well poised, but this has I think been accomplished at too great a sacrifice of the dictates of sensibility with too great a denial of vital quality in the forms.

Roger Fry: *Cézanne*, Hogarth Press Ltd., London, 1930

Cézanne was not a great classic: he was an artist, often clumsy, always in difficulties, very limited in his range, absurdly so in his most numerous productions, but with 'quite a little mood', and the haunting idea of an art built upon the early Manet, at which he could only hint. He oscillated between Manet's earlier and finer manner, that of marked contours and broadly decided colour, and a painting based on the early Monet, all colour in a high key. In this manner he

produced certain landscapes, tender and beautiful in colour but the figure was too difficult for him, and from difficulties of all sorts he escaped into the still-lifes I have spoken of, flattened jugs, apples, and napkins like blue tin that would clank if·they fell. What is fatal to the claim set up for him as a deliberate designer, creating eternal images out of the momentary light of the Impressionists, is the fact that his technique remains that of the Impressionists, a sketcher's technique, adapted for snatching hurriedly at effects that will not wait. Hence his touch, hence those slops of form out of which he tries to throw a figure together. No one was ever further from logical 'classic' construction, if that is what we are looking for; none of the Impressionists was so uncertain in his shots at a shape. And when we come to fundamentals, to rhythm, whether it be the rhythm of the thing seen, or the rhythm of the picture imagined... Cézanne is helpless.

D.S. Macoll: *Confessions of a Keeper*, Maclehose, London, 1931

Cézanne was fated, as his passion was immense, to be immensely neglected, immensely misunderstood, and now, I think, immensely overrated... after all acknowledgement has been made of a certain greatness in his talent. The moral weight of his single-hearted and unceasing effort, of his sublime love for his art, has made itself felt. In some mysterious way, indeed, this gigantic sincerity impresses and holds even those who have not the slightest knowledge of what were his qualities, of what he was driving at, what he achieved, or of where he failed... The difficulties that a painter must always experience with the Cézanne cult are the very real beauty of the tiny percentage of Cézanne's successes, and the immense respect and sympathy inspired by Cézanne's character and industry. To criticise him is, morally, almost like criticising an artist without arms who has aroused the very proper sympathy and patronage of royalty.

W.R. Sickert: *A Free House*, Macmillan, London, 1947

Everyone in the course of that (the 19th) century had supposed that painting was a visual art; that the painter was primarily a person who used his eyes, and used his hands only to record what the use of his eyes had revealed to him. Then came Cézanne and began to paint like a blind man. His still-life studies, which enshrine the essence of his genius, are like groups of things that have been groped over with the hands; he uses colour not to reproduce what he sees in looking at them but to express almost in a kind of algebraic notation what in this groping he has felt... It is the same when Cézanne takes us into the open air. His landscapes have lost almost every trace of visuality... it is a perplexing mixture of projections and recessions, over and round which we find ourselves feeling our way as one can imagine an infant feeling its way, when it has barely begun to crawl, among the nursery furniture. And over the landscape broods the obsession of Mount Sainte-Victoire never looked at, but always felt, as a child feels the table over the back of its head.

R. G. Collingwood: *Principles of Art*, Oxford University Press, 1938

Cézanne's classic and symbolic triumph has nothing of the direct expressionist consummation towards which the original impetus points. We learn more about the positive force of his abstracted recreation if we look again at the opposite state, shown to us in the painting and poetry of his youth. At the crux of *Une Terrible Histoire* a woman, the most beautiful he has ever seen, calls the poet to her. Throwing himself before her, he kisses with guilty lips her breast, but on the instant the chill of death seizes him: the woman in his arms is changed to a corpse, to a rattling skeleton. The terror is real. The fantasy, though we rarely meet it so undisguised, is one that we recognize. Analysis of the pictures of Cézanne's twenties would reveal much of the same theme: their force carries a burden of grief. There was a fatality inherent in the direct embrace. The mature style made it good; it enfolded the visible world in an embrace which was itself a reparation, a lasting recreation of the object of love. In his art, as in his utterances, what is stable and durable has a special meaning. Whatever might prove transitory in his grasp was excluded from it, for the nature of change was predetermined and terrible: he could possess only a form as lasting as the art of the museums. The virtue of the living world before his eyes was that it remained real and alive. He assured himself of

its continued existence at each look; each touch, owing nothing to the last, could record that its virtue was undiminished.

Lawrence Gowing (from the catalogue of the Arts Council's Cézanne Exhibition, 1954)

To us it seems that for Cézanne that moment when his eyes were crossing and recrossing the visible surfaces of the natural world, apples and ginger-jars, or trees, rocks and houses—that that was the moment when the vitally significant rhythms of his inner vision came most clearly to consciousness, suddenly projecting themselves, mirage-like, *between* the painter and the scene that he contemplated: a dancing imagery *that was the transformation* he so desperately, so persistently sought for those apples and those trees. The tension between 'inner' and 'outer' was thus perfect; the inner appearing only when he had given himself up completely to the 'study' of the outer. There is not the slightest doubt that Cézanne was in a frenzy to 'express himself', as we say. But this explosive force within was never allowed to emerge neat and undiluted. It was never allowed to flood out on to canvas as a furiously incoherent slashing and stabbing of pigment. Cézanne opposed this interior surge by a desperate discipline—he forced it to express itself entirely in terms of images of the sunlit, exterior world—images which, in their turn, also presented themselves to him with an almost overwhelming force. Therefore, his art was an equation of two great streams of experience—one from inside himself; the other from outside.

Cézanne's watercolours have given new status to their medium... something at once monumental and utterly delicate; aerially immense and supremely indicative of volume and sculptured form, yet intimate, sweet and clear, as all that does no violence to a paper host must be. Cézanne's watercolours are, in short, no substitute: sketch or impression would be words of little accuracy...

If white paper would seem to confound these remarks, I must point out how used are the white areas which lie scattered thick as archipelagoes across these pictures. I would almost say that in them the expression is at its most intense; that it is precisely the white patches that are most potent in form, almost building from the surface with the movement and light which is concentrated in them. The flakes of colour which alight in definition *round* the forms contemplated, overlap one another with rainbow richness, stating and restating contours and planes in the unending attempt to capture the essential aspect, the heart of form. White is where he dared not tread: the vital node of every form, where false statement would destroy the whole. White is the unstateable core of each coloured snowstorm of definitions; and its potency derives from the fact that every slanting stroke at the perimeter throws definition inwards, adds meaning to the white!... doubt and certainty lie side by side in every gesture of the brush; for Cézanne's humility before sensation and his overwhelming conviction in the experience of that sensation are both present, and obvious, in every picture he ever painted. Hesitation—conviction: hesitation—statement: he maintained and endured the tension like a saint, never yielding to the temptation to produce synthetic unity, to work the picture together on a level other than that of his peculiar conviction...

I have long known Cézanne's austerity; what attacked me lately was the great tenderness of feeling: the brilliant early foliage of the curving lane: the purple-gold light of afternoon on the mountain: the green winking of a bottle amongst the minor suns of yellow-red apples: the blue and white dazzle of morning light in the trees. So much for the theorists' abolition of 'the subject'!... the *significant form* of an apple derives at least as great a part of its significance from its connection with that apple as from the fact that it exists in the category of 'form'.

Patrick Heron: *The Changing Forms of Art*, Routledge & Kegan Paul, London, 1955

Biographical outline

1839 January 19th. Born in Aix-en-Provence, eldest of three children. His father, a domineering self-made man, was a partner in a bank founded in Aix in 1848. His parents were married in 1844. The family stood aloof from local society.

1848-58 At school in Aix. Met Zola 1852. Adolescent years spent in the constant company of Zola and Baptistin Baille, absorbing music, passionate poetry and the savage Provençal landscape.

1858-9 Zola left Aix for Paris. Cézanne entered the Drawing Academy in Aix.

1859-61 Studied law at Aix University. His father bought Jas de Bouffan, a country house outside Aix (1859). Occasional study at the Drawing Academy. Determined to become a painter.

1861 Abandoned his law studies. First visit to Paris. Met Pissarro at the Atelier Suisse.

1861-2 Worked in his father's bank.

1862 Took up painting again. Returned to Paris. but failed entrance examination for the Ecole des Beaux Arts. Stayed in Paris till 1870, with visits to Aix. Worked at the Atelier Suisse and in the Louvre.

1863 Exhibited at the *Salon des Refusés*. Met Guillaumin and Guillemet.

1864-70 Rejected at the Salons of 1864, 66, 67, 68, 69, despite the support of Daubigny, the championship of Zola and the praise of Manet. In 1866 Cézanne protested to the Director of Fine Arts. His paintings comprised violent imaginative subjects and the *Couillarde* still-lifes and portraits. Met Valabrègue and Marion (1865).

1870-1 Worked at l'Estaque, living with a model Hortense Fiquet. Their son Paul born in Jan 1872.

1872-3 Worked at Pontoise with Pissarro; copied one of his paintings. Influenced by Impressionism. Concentrated on objective painting from the motif.

1873-4 Worked at Auvers. Met Dr Gachet.

1874 Three paintings at the First Impressionist Exhibition.

1875 Aix and Paris. Chocquet bought a Cézanne from Tanguy. Introduced to Chocquet by Renoir, painted his portrait.

1876 Aix and l'Estaque. Rejected at the Salon. Declined to contribute to the Second Impressionist Exhibition.

1877 Sixteen paintings at Third Impressionist Exhibition.

1878 Aix and l'Estaque. Rejected at the Salon. His father discovered his secret relationship with Hortense and tried to break it. Zola helped him financially.

1879 L'Estaque and Melun. Rejected at the Salon, despite the support of Guillemet, now a jury member.

1880 From this point on, spent increasingly less time in Paris. Worked mainly in Aix with frequent visits to l'Estaque and occasional painting excursions elsewhere. Zola's support for his art waning. Rejected at the Salons of 1881, 83, 84, 85, 86.

1881 Met Gauguin in Paris. Later became violently opposed to Gauguin's concepts of art, warned younger painters against him.

1882 Worked at l'Estaque with Renoir. A portrait accepted at the Salon, as 'pupil of Guillemet'.

1883 With Monticelli at l'Estaque for part of the year. Then with Monet and Renoir.

1884 Signac bought a Cézanne from Tanguy.

1885 Mysterious love affair. Confided in Zola.

1886 Zola published *L'Oeuvre*; Cézanne – hurt by obvious references to himself in the main character – breaks their relationship. Married Hortense Fiquet with parents' approval. His father died and Cézanne's inheritance made him financially independent.

1889 *Le Maison du Pendu* shown at the Paris World's Fair at Chocquet's initiative.

1890 Showed three paintings with *Les XX*, Brussels. Visit to Switzerland. Began to suffer from diabetes.

1892 Emile Bernard published article on Cézanne. At around this date Cézanne became a devout catholic.

1894 With Monet at Giverny in the autumn. Met Rodin and Geffroy. Pissarro encouraged the dealer Vollard's interest in Cézanne.

1895 Vollard mounted the first of his Cézanne exhibitions, this one of one hundred and fifty paintings. Later in the 1890s Vollard bought the entire contents of one of Cézanne's studios. Two Cézannes entered the Luxembourg with the Caillebotte bequest.

1896 Met Gasquet. A Zola article described Cézanne as an 'abortive genius'.

1897 Disagreed with Zola's campaign over the Dreyfus affair. Started working at Bibémus Quarry.

1899 Sale of Jas de Bouffan to settle the family estate after his mother's death. Tried in vain to purchase Château Noir where he had been painting. Worked from rented premises in and around Aix until 1902. Death of Chocquet and sale of his collection.

1900 Three paintings at Centennial Exhibition, Paris.

1901-2 His own studio built on the Chemin des Lauves, Aix. Met Camoin.

1903 Three paintings exhibited at the *Salon des Indépendants*. Death of Zola.

1904 Visited at Aix by Bernard; lengthy correspondence followed. Exhibited nine paintings at *La Libre Esthétique*, Brussels and others at the *Salon d'Automne*.

1905 Ten paintings at the *Salon d'Automne*.

1906 Visited by Denis, Roussel and Camoin. Listed himself in a catalogue as 'pupil of Pissarro'. Ten paintings at the *Salon d'Automne*.

1906 October 22nd. Death of Cézanne.

SELECTED BOOK LIST

ZOLA, Emile: *L'Oeuvre*, Paris 1886.
Mes Haines, Paris 1923.

DENIS, Maurice: *Théories, 1890-1910*, Paris 1912.

VOLLARD, Ambroise: *Paul Cézanne*, Paris 1914, New York 1926.

GASQUET, Joachim: *Paul Cézanne*, Paris, 1921.

FRY, Roger: *Cézanne, A Study of his Development*, London 1927.

REY, Robert: *La renaissance du sentiment classique*, Paris 1931.

VENTURI, Lionello: *Cézanne, son art, son oeuvre*, 2 vols, Paris 1936.
Paul Cézanne – Water Colours, London 1943.

CEZANNE, Paul: *Letters*, edited by John Rewald, London 1941.

LORAN, Erle: *Cézanne's Composition*, Los Angeles, 1944.

STOKES, Adrian: *Cézanne*, London 1947.

DORIVAL, Bernard: *Cézanne*, Paris 1948.

REWALD, John: *The Ordeal of Paul Cézanne*, London 1950.
The History of Impressionism, New York 1946.

SCHAPIRO, Meyer: *Cézanne*, New York 1952.

GOWING, Lawrence: Introduction to Arts Council Catalogue, London and Edinburgh 1954.

COOPER, Douglas: *The Courtauld Collection*, London 1954.

CHAPPUIS, Adrien: *Dessins de Paul Cézanne au Cabinet des Estampes du Musée des Beaux-Arts, Basel*, Lausanne 1963.

Notes on the plates by Nicholas Wadley

Plate 1 *Head of an Old Man.* 1865-8. 20 × 18 ½ in. (51 × × 48 cm.). Louvre, Paris.

Nearly all of Cézanne's early works were excitedly heavy in paint. His immature handling ranged from a nervous agitation (plate 5) to his thickly pasted palette knife style (plate 2). Both qualities are present in this painting: in the animated execution of the hair and face and the attacking marks that imply the sitter's clothes. Cézanne's friend Valabrègue, who also sat for him, wrote to Zola 'Every time Cézanne paints one of his friends he seems to avenge himself for some hidden injury'. (1866)

Plate 2 *Still-life, Skull and Candlestick.* 1865-7. 18 ¾ × 24 ⅜ in. (47.5 × 62.5 cm.). Private collection, Switzerland.

A lesser-known example of what he called his 'couillarde' style. The word 'Couillarde', one of the less genteel colloquial categories in art terminology, was used by Cézanne to express the lusty and essentially masculine aggression of his palette knife technique. In its rather adolescent lack of refinement it epitomises the temperamental character of his immature oeuvre. The whole canvas is loaded with paint, aggressively laid on with palette knife, almost in low relief. The inclusion of the skull, a frequent motif in Cezanne still-lifes, reflects the morbid preoccupation with death of his adolescent writings.

Plate 3 *The Temptation of St Anthony.* 1869-70. 22 ½ × 30 in. (57 × 76 cm.). Buhrle Collection, Zurich.

A typical example of Cezanne's early romantic paintings. Their subjects were usually violent and often erotic, including scenes of murder, orgy and rape. This particular subject was to become a constant theme for the 'decadents' and symbolists in the 1890s. The oppressive colour and the nervous agitation of the handling endow these subjects with black foreboding and a Baroque tremulousness. These paintings parallel his own poetry, the dreams of conquest discussed in letters with Zola, as well as his early taste in art. In Zola's novel *L'Oeuvre* (whose publication in 1886 so upset Cezanne as to end their long friendship) the author describes Cezanne's work by inference as follows: 'It was a chaste man's passion for the flesh of women, a mad love of nudity desired and never possessed, an impossibility of satisfying himself, of creating as much of this flesh as he dreamed to hold in his frantic arms. Those girls whom he chased out of his studio he adored in his paintings; he caressed or attacked them, in tears of despair at not being able to make them sufficiently beautiful, sufficiently alive.'

Plate 4 *The Black Clock.* 1869-70. 21 ¾ × 28 ¾ in. (54 × × 73 cm.). Private Collection, Paris.

The outstanding early still-life. Its massive structural strength demonstrates the increasing control of Cézanne's handling. The colour scale is dominated by the off-whites and blacks he admired in Manet's painting. But even in this ostensibly formal study, the gaping red lips of the shell introduce a macabre and erotic element. Some writers have also seen the handless face of the clock as an enigmatic symbol.

Plate 5 *A Modern Olympia.* 1872-3. 18 × 21 in. (46 × 55 cm.). Louvre, Paris.

At the First Impressionist Exhibition in 1874 this painting achieved a *succès de scandale* almost as great as that of the Manet masterpiece it parodies. Even in the company of the Impressionists — whose collective work presented the public with revolutions of colour and technique that were very difficult to accept — this Cézanne with its scribbles of raw colour and bizarre subject must have appeared the extreme outrage. The verdict that 'Cézanne merely gives the impression of being a sort of madman who paints in *delirium tremens*' is understandable in the context. *A Modern Olympia* is the last important expression of the turbulent, barely-controlled self-expression of his artistic adolescence. The autobiographical element of the early work is demonstrated here by the caricatured self-portrait, the seated admirer before whose gaze the hunched, red-flecked nude is unveiled. The grotesque transformation of Manet's cat almost suggests a self-mockery after the impassioned commitment of most of his early subject painting.

Plate 6 *The House of the Hanged Man.* Auvers, 1873. 21 × 26 ¼ in. (55.5 × 66.5 cm.). Louvre, Paris.

This was also exhibited at the First Impressionist Exhibition 1874. *A Modern Olympia* was the last work of the young Cézanne, this was the first major statement of the maturing

Cézanne. Under the influence of Impressionism — and particularly of Pissarro with whom he worked at Pontoise 1872-73 — the energy of Cézanne's passionate compulsion to paint was diverted from imaginative introversion to an objective study of landscape. Considering the stubborness of Cézanne's temperament (Zola once said 'to convince Cézanne of anything is like teaching the towers of Notre Dame to dance') this total conversion of his art is quite extraordinary. Cézanne later spoke of 'the humble and colossal Pissarro' and their deep mutual respect must have played a vital role in the transformation.

Plate 7 *Auvers: Village Panorama.* 1873-5. 25½ × 31¾ in. (65 × 81 cm.). Art Institute of Chicago. Mr and Mrs Lewis L. Coburn Memorial Collection.
As early as 1866 Cézanne had told Zola 'I can improve on the old masters by painting out of doors.' Now, in the mid-1870s, he did little else and even when his motif was a model or still-life, he sat in front of it and what he *saw* provided all his terms of reference. This painting also illustrates the other two effects of Impressionist influence. Firstly a change of his palette away from the black-dominated opaque range of the 1860s to a clearer lighter colour scale. Secondly the Impressionist technique of broken brush strokes which became the basis of a more regular system of brush marks. The significant difference from Impressionism at this point is the emphasis given to local colour. The interaction between red, blue and purple rooftops is the central focus of this picture's colour structure.

Plate 8 *Dahlias in a Delft Vase.* 1873-75. 28¾ × 21¼ in. (73 × 81 cm.). Louvre, Paris.
This work was painted in the Auvers home of Dr Paul Gachet who was one of the most remarkable amateurs of late 19th-century France. Himself a painter (under the pseudonym of Van Ryssel), he was a friend and supporter of Pissarro, Cézanne, Gullaumin and Van Gogh. The richly impasted dense colour of this painting resembles the still-lifes of the Provençal painter Monticelli whom Cézanne knew and admired. It is one of eight Cézannes from Gachet's collection that are now in the Louvre's Musée de l'Impressionisme. The Delft vase was given to the Jeu de Paume by Gachet's family in 1951.

Plate 9 *Portrait of Victor Chocquet.* 1876-7. 18 × 14 in. (45.5 × 35.5 cm.). Lord Rothschild Collection, Cambridge.
Chocquet succeeded Zola as Cézanne's moral and spiritual support, from their meeting in 1875 until Chocquet's death in 1899, when his collection included 32 Cézannes. Cézanne envied Chocquet's intellectual stamina and calm. The 1886 letter to Chocquet, quoted on page 17, expresses well the nature of Cézanne's admiration. This rugged idealisation is one of the earliest of a series of portraits of Chocquet.

Plate 10 *Still-life with Apples and Biscuits c.* 1877. 14⅞ × 21½ in. (38 × 55 cm.). Louvre, Salles de l'Orangerie, Paris.
The still-life became an important motif for Cézanne. Its passive, constant and relatively inanimate character allowed him uninhibited control and analysis. Its frequent use as a genre by artists like Mondrian in their development towards total non-figuration reflects this quality. In Cézanne's hands the genre became a rich and varied vehicle. He devoted endless care to arranging the motif, plotting campaigns of form and colour. During the painting, local colours, tonal massses and linear patterns are opposed, modified, sometimes transformed, until the complex and dynamic relationship is resolved. Local colour as a means of emphasis and identity plays a particularly important role in the dynamics of his still-life compositions.

Plate 11 *Self-portrait. c.* 1879. 13¾ × 10⅝ in. (35 × 27 cm.). Tate Gallery, London.
Most of Cézanne's self-portraits are subdued in colour and contemplative in mood. The instinct to organise is ever-present. It is as clear here in the opposition of soft to hard as in the homogeneity of the limited palette's distribution. Colour and form revolve around the hypnotic brown eye strongly enough to convince us that it is the centre of the canvas. The angular pattern resists actual collision with the bald dome of his head, but their points of potential contact are as powerful as a halo. Part of Cézanne's achievement lies in the marriage of this 'architecture' to a real experience of a human presence.

Plate 12 *Auvers from the Harmé Valley.* 1879-82. 28¾ × 36 in. (73 × 92 cm.). Kunsthaus, Zurich.

After his virtual withdrawal from Parisian art circles around 1877, Cézanne worked mainly in Aix with occasional visits to l'Estaque and Auvers where he painted this. Later he described his retreat: 'I resolved to work in silence until the day when I could defend theoretically the result of my efforts.' Plates 12, 13, 15, 17 are examples of the ordered discipline he imposed on his motifs around 1880. The regularised Impressionist brush strokes combine to form bigger parallel units, which in turn create the broad tone and colour masses. The network of hatching endows the surface with a stable unity. Within this unified texture, changes of direction in the hatching obtain dramatic force.

Plate 13 *L'Estaque: the Village and Sea.* 1879-83. 20 ½ × 24 ¾ in. (52 × 63 cm.). Siegfried Rosengart Collection, Lucerne.
Cézanne first worked at l'Estaque in 1870 when he lived there secretly with Hortense Fiquet, his future wife — hiding this fact from his formidable father and hiding himself from conscription for the Franco-Prussian war. Zola's description of the terrain there embodies much of Cézanne's feelings about southern France. See also notes to plates 12 and 19. 'The country is superb. The arms of rock stretch out on either side of the gulf, while the islands, extending in width, seem to bar the horizon, and the sea is but a vast basin, a lake of brilliant blue when the weather is fine... When the sun falls perpendicularly to the horizon, the sea, almost black, seems to sleep between the two promontories of rocks whose whiteness is relieved by yellow and brown. The pines dot the red earth with green. It is a vast panorama, a corner of the Orient rising up in the blinding vibration of the day.'

Plate 14 *The Lady with the Fan: Mme Cézanne.* 1879-82. 36 ¼ × 28 ¾ in. (92 × 73 cm.). E. G. Bührle Collection, Zurich.
The portraits of his wife (see also plate 31) are severe and not particularly feminine. Tales of his love/hate mistrust of women are legion, but the early romantic pictures (plates 3, 5) and the later *Bathers* (plates 46, 47) are a better expression of this than his portraits. He was rigorously demanding of his sitters. They endured many long sessions in which move-

ment was not allowed and conversation not encouraged. He expected a sitter to behave like a still-life and treated him or her very much as such in the painting. He was more concerned with exploring and exploiting outward identity than with expressing inner character.

Plate 15 *Poplars.* 1879-82. 24 ⅜ × 30 ¾ in. (61.5 × 78 cm.). Louvre, Paris.
Several of the tall vertical shafts are almost imperceptibly inclined. The receding lines of the foreground track are played down. The line of the little winding path is broken across. The density and colour of the foliage has equality between the nearest and furthest points. All are devices to control recession. And yet this picture is a perfectly lucid transcription of a densely wooded landscape. Cézanne said there are two things in the painter, the eye and the mind: that he must develop both his sensations and a method ('logic' he called it) for realising them. But for him the method must be as intuitive as his perception and as deeply based on contemplation of nature. The painter must not 'interfere'. These 'distortions' derive from his looking.

Plate 16 *Self-portrait.* c. 1880-81. 10 ¼ × 5 ⅞ in. (26 × 15 cm.). Louvre, Paris.
Painted with the same palette as the barren landscape on the facing page, the same deliberate stroke by stroke construction, the same interrelated colour structure, this tiny sketch which once belonged to Pissarro (presumably a gift) is unusual among Cézanne's unfinished works (see plates 25, 33, 37) in being virtually complete in one area and scarcely coloured elsewhere.

Plate 17 *Rocks at l'Estaque.* 1882-85. 28 ¾ × 33 ¾ in. (73 × 91 cm.). Museum of Art, São Paulo.
This is an outstanding example of the insistent hatched execution of Cézanne's middle period, which knits all the parts into a single fabric. Within this unity there is a complicated balance between colour, tone and line. The successive planes are clearly defined: their overlapping suggests recession and a broken contour line is used sporadically to emphasise this. But this in turn is counteracted by the alternation of cool and warm dominant colours, almost plane-by-plane in this picture.

Plate 18 *Mount Marseilleveyre.* 1882-5. 20 × 24 in. (51 × 62 cm.). Private Collection, Switzerland.
A view from l'Estaque. See note to following plate.

Plate 19 *The Bay of Marseilles seen from l'Estaque.* 1882-5. 22 ¾ × 28 ¼ in. (58 × 72 cm.). Louvre, Paris.
It was from l'Estaque that Cézanne wrote to Pissarro in 1876 in astonishment, that the landscape looked like a playing card': the strong sunlight of the Mediterranean coastline appeared to silhouette the objects and isolate the local colours. (The letter is quoted on page 17). The fact that Cézanne was born and spent most of his working life in southern France, where these conditions prevailed, conditioned his perception. On the strength of this alone, his visual instincts and education were essentially different from those of the Impressionists. The channel coast and the Ile de France, native environments for Monet and Renoir, are worlds of dissolving light and the 'atmospheric envelope'. The distant skyline in this painting is as solid as a bronze relief; the blue of the bay if anything gains in intensity as it recedes. The softer atmospheric treatment of the background, with no compensatory values, in plate 18, is unusual and out of character in Cézanne's oeuvre.

Plate 20 *The Little Bridge, Mennency.* 1882-5. 23 ⅝ × 28 ⅝ in. (60 × 73 cm.). Louvre, Paris.
Originally in Chocquet's collection. The crisp brushwork and clear colour separation exemplify in an extreme form the severe architectural structure of Cézanne's 1880s landscapes. The use of reflections, as sharply defined and as solidly impasted as the motif itself, enforces the concrete reality of the whole picture surface. (Plate 41 shows another instance of this.) Monet obtained a similar effect — more through colour than drawing — in *his* later water subjects.

Plate 21 *Still-life with Soup Tureen.* 1883-85? 25 ½ × 32 in. (65 × 81.5 cm.). Louvre, Paris.
Some eminent scholars date this painting *c.* 1875-77. It belonged to Pissarro and the composition includes a Pissarro street scene in the background. The composition is restrained. The drawing of the picture frames is deliberately lost in some passages, then strongly restated in the welding of foreground to background. The blue of the wall breaks across the tablecloth, the warmth of the fruit infects the wall above them. The painted birds, scarcely contained by their frame, almost join the robust forms on the table in three dimensional plasticity.

Plate 22 *Jas de Bouffan.* 1882-5. 23 ¾ × 28 ¾ in. (60.5 × 73.5 cm.). National Gallery, Prague.
The Jas de Bouffan was the country house and estate of Cézanne's father, bought when Cézanne was twenty and inherited by him at this father's death in 1886. In 1889 Cézanne reluctantly sold the house which had featured so largely in his art — as a site for his bizarre murals of around 1860, as a motif for many paintings of the 80s and 90s and as a home in the midst of his beloved Provençal landscape. In the interests of this painting's overall harmony, Cézanne was prepared to tilt the massive structure as if in the throes of subsidence, just as he tipped a plate in a still-life.

Plate 23 *Trees at the Jas de Bouffan.* 1885-87. 25 ½ × 31 ¼ in. (64.5 × 79 cm.). Courtauld Institute Galleries, London.
Adrian Stokes' remark that 'a better image perhaps both for the division of Cézanne's volumes and for their interaction, is of trees reflected in slightly undulating water' could be a commentary on this painting. The canvas is alive with interacting rhythms — created here principally by the directional brush strokes — with references to surface and depth and to the opaque and the transparent.

Plate 24 *The Blue Vase.* 1885-7. 24 × 19 ⅝ in. (62 × 51 cm.). Louvre, Paris.
A masterpiece of sensitivity among the important still-life paintings of *c.* 1885-95. The paint is thinner now, the colours more distinct and luminous, the relationships of colour and form more delicate, but no less complex. In many ways this technique anticipates the fluent manner of his last landscapes (see plate 45). The deliberate lack of coincidence between colour area and contour in the foreground fruit becomes a crucial device.

Plate 25 *Trees and Houses.* 1885-7. 26 ¾ × 36 in. (68 × 92 cm.). Lehman Collection, New York.

The paint is thin, almost as translucent as watercolour. The unfinished state reveals Cézanne's dictum 'I advance all my canvas at the same time'. With the canvas barely covered in places, the conversation between colours, tones and lines is already in progress throughout the painting.

Plate 26 *Mont Ste Victoire.* c. 1886-8. 26 × 35 ¾ in. (66 × 89.5 cm.). Courtauld Institute Galleries, London.
This mountain was to become one of Cézanne's favourite landscape motifs in his last years. Its monumental shape, dominating the local landscape, assumed an almost symbolic role for Cézanne: a symbol of Poussinesque eternity in nature and of the 'more solid and durable' art that he wanted to build from Impressionism. Here its distant contour is echoed in the disposition of foreground foliage, bringing it forward to command the picture surface.

Plate 27 *Aix: Rocky Landscape.* c. 1887. 25 ⅝ × 31 ⅞ in. (65 ×81 cm.). National Gallery, London.
The scale of tone, definition and colour-change carries tremendous implications of space and distance. Nevertheless the whole structure, from the massive foreground modelling to the faint patchwork of hillside fields, is ruthlessly enclosed between the two elliptical contours. 'One must not reproduce nature,' Cézanne wrote, 'one must interpret it. By what means? By means of plastic equivalents and of colour.'

Plate 28 *Harlequin.* c. 1889. 36 ×25 ½ in. (91 × 64.5 cm.). Lord Rothschild Collection, Cambridge.
One of three paintings of this traditional subject; a fourth (*Mardi Gras*) represents Harlequin and Pierrot. The very identifiable costume strikes an odd note in Cézanne's figure paintings. In this particular version its design is insisted upon, making an unusually consistent passage of unbroken local colours from the abstracted head to the opaque paint of the floor. This foreground was extended by an additional strip of canvas (about 4 inches wide) during the painting. The disturbing mood of the picture anticipates Picasso's treatment of the same subject.

Plate 29 *Still-life with Fruit Basket.* c. 1888-90. 25 ½ × 32 in. (91 × 64.5 cm.). Louvre, Paris.

One of the more complex still-life paintings, not only in the richness of the actual motif, but in the whole range of adjustments imposed on that motif during the painting. The discontinuous line of the table top; the tilted ellipses of jug and ginger pot; the precarious perch of the basket; the mysterious appearance, far right, of a chair leg (?) that appears to touch the floor in mid-air; all these features within Cézanne's concept of painting create the forces and tensions whose collision and balance constitute what he called 'plastic equivalents' to reality.

Plate 30 *Pot of Flowers and Pears.* c. 1880-90. 17 ¾ × 21 ¼ in. (45 × 53.3 cm.). Courtauld Institute Galleries, London.
Very similar in its simplicity to *The Blue Vase* (plate 24): strong clear colours contained within a deceptively simple structure. The far edge of the table appears at four different heights, assuming both horizontal and diagonal character, till it merges with the zigzagging tilted canvas at the right. This general type of composition — a central complex of forms towards which other angular elements converge — was repeatedly used by Cézanne in still-lifes and portraits, and later richly exploited by the Cubists.

Plate 31 *Portrait of Mme Cézanne in Red.* c. 1890. 35 × 27 ½ in. (89 × 70 cm.). Museum of Art, São Paulo.
Compared with the portrait of some ten years earlier (plate 14), this is dramatically simple in its thin paint, its palette of almost two colours and its severe off-vertical composition. The blue ground contains soft reflections of the red dress and is itself picked up in the sitter's face and hands. Notice how the left cuff suddenly breaks continuity with the rest of the sleeve. Cézanne had lived with Hortense Fiquet since 1870; they were married in 1886.

Plate 32 *Card Players.* c. 1893. 23 ½ × 28 ¾ in. (59.5 × 73 cm.). Courtauld Institute Galleries, London.
Cézanne painted five versions of this subject. In two of them other figures are involved, but mostly he concentrated on the tense opposition of two figures that obviously attracted him to the subject. About the vertical axis (emphasised throughout the central passage) there is a rich play of contrasted angles, tones and silhouettes. The off-true horizontals that link

the two figures increase the dynamics of their relationship.

Plate 33 *Still-life with Water Jug.* c. 1892-3. 20 ⅞ × 28 in. (53 × 71 cm.). Tate Gallery, London.
This is an excellent example of Cézanne's working method. From the outset a full range of relationships is established on the canvas. Hereafter the painting's progress is a matter of sustaining and refining these relationships with constant reference to the motif rather than of covering the canvas (see also note to plate 43).

Plate 34 *Man Smoking a Pipe.* c. 1892. 28 ¾ × 23 ½ in. (73 × 59.5 cm.). Courtauld Institute Galleries, London.
The sitter was a gardener at the Jas de Bouffan who also posed for three of the *Card Players* pictures (see plate 32). The free play between contour and impasto in the painting of the hat and the translucent luminosity of the face and shirt are characteristics of his fully developed manner.

Plate 35 *Boy in a Red Waistcoat.* 1890-5. 31 × 25 in. (79 × 64 cm.). E. G. Bührle Collection, Zurich.
One of the masterpieces of the 1890s. The exuberant bloom of the colour is matched by the fresh paint and strong free drawing. After the discipline of the 1880s there is a renewed sense of richness and release, though still within the basic context of objective looking. The extraordinary distortions of the two arms that contribute so enormously to the dramatic diagonal composition Cézanne would have justified in terms of his sensations before the motif. ('If I think... everything is lost'.) The left hand that becomes a second contour for the tiny head and the subtle softening of the dark horizontal as it meets the brow endow the painting's climax with a dynamic fullness.

Plate 36 *Vase of Tulips.* 1890-4. 23 ½ × 16 ⅝ in. (59.6 × 42.3 cm.). Art Institute of Chicago. Gift of Annie Swan Coburn to the Mr and Mrs Lewis L. Coburn Memorial Collection. A simple composition of monumental forms overlaid with an intricate network of formal echoes and colour relationships. These start from the crucial dissimilarity of the vase's two profiles. 'Painting is not the servile copying of the objects but the discovery of harmony among numerous relationships' (Cézanne).

Plate 37 *The Bathers.* 1890-4. 8 ½ × 12 ½ in. (22 × 33 cm.). Louvre, Paris.
This subject is the most problematic in Cézanne's oeuvre. It is almost unique in being an imagined rather than an experienced motif, and the only theme running right through his career that links in this sense with his adolescent romantic paintings. Lawrence Gowing has suggested that Cézanne, conscious of the European figure-tradition looking over his shoulder, was trying to reinterpret his early subjects 'as if he could see them'. The idea is convincing. What is certain though is that Cézanne never resolved the ambition with conviction. The nervous excitement and hesitance of mark in this painting seem — by comparison with other works of the period — to be born of emotional uncertainty not passionate humility. (See also note to plates 46, 47).

Plate 38 *Still-life with Plaster Cast.* c. 1895. Oil on paper on wood. 26 ½ × 22 ½ in. (69.5 × 57 cm.). Courtauld Institute Galleries, London.
Full of ambiguities and of free play between the actual and the painted, this is another great landmark of the 90s. The great curving void that dominates the composition, more positive than negative, is typical of the more organic rhythms of Cézanne's late style. The plaster is a cast after the Louvre *Cupid* by Puget, whose expressive figures exerted some influence on Cézanne. He made several studies after Puget (see figures 3, 4).

Plate 39 *Portrait of Joachim Gasquet.* 1896-7. 25 ⅝ × 21 ¼ in. (65.6 × 54.4 cm.). National Gallery, Prague.
Joachim Gasquet, poet and historian, was one of the first of several younger men who became admirers and friends of Cézanne in his later years. Cézanne, suspicious and reserved by nature, was deeply moved by their respect and admiration after years of self-imposed solitude. It is largely through correspondence with them, and especially the young painter Emile Bernard, that Cézanne made the important theoretical statements of 1900-6.

Plate 40 *The Clockmaker. c.* 1895-1900. 36 ½ × 28 ¾ in. (92.5 × 73.5 cm.). Solomon R. Guggenheim Museum, New York. Apart from portraits of his friends (plates 39, 43) and his wife, most of his figure studies were sat for by local people from Aix (see also plates 32, 34, 42). Drawing dominates as the main structural element in this portrait and here — as in plates 39, 42 and 43 — the use of the double or multiple line to give vibrant contour to a volume is clearly evident.

Plate 41 *The Lake of Annecy. c.* 1896. 25 ½ × 32 in. (64.5 × 81 cm.). Courtauld Institute Galleries, London.
Cézanne described the setting of this motif rather disparagingly: 'To be sure it is real nature, but a little as we have been taught to see it in the albums of young lady travellers'. The painting is far from effete. In its aggressive strength — sky like mountains, water like architecture — it recalls the relief plasticity of his *couillarde* manner.

Plate 42 *Old Woman with Rosary. c.* 1897-8. 31 ¾ × 26 ¾ in. (81 × 65.5 cm.). National Gallery, London.
The old woman, a former nun, was employed by Cézanne as a maid. The massive central form of her body — its outlines stated, painted out and then restated time and again — almost merges with the dark shapes that converge towards it. The simplification of the face again anticipates early cubist painting.

Plate 43 *Portrait of Ambroise Vollard.* 1899. 39 ½ × 31 ½ in. (100 × 81 cm.). Petit Palais Museum, Paris.
Exemplifying the proto-cubist Cézanne *par excellence*, this painting is built from the close knitting of lines and brushed planes within a very tight colour scale. Vollard, the Parisian dealer and publisher, endured the endless sittings (over one hundred) imposed on all Cézanne's models. At a late stage he asked Cézanne about the patches of bare canvas still showing through the hands, to which Cézanne gave the famous reply: 'if I put something there by guesswork I might have to paint the whole canvas over, starting from that point'. This silenced Vollard of course.

Plate 44 *Still-life with Apples and Oranges.* 1896-1900. 28 ¾ × 36 ½ in. (73 × 93 cm.). Louvre, Paris.

A baroque campaign among the battle of forces that Cézanne's still-lifes comprise. The canvas is alive with those punctuations of vivid local colour of fruit, one or two of which in other pictures make the main drama. Cézanne's unexpected statement that 'Painting stands for no other end than itself. The painter paints an apple or a head; it is for him a pretext of lines and of colours and nothing more', seems borne out by his still-lifes at first consideration. It was certainly this detached art-for-art's sake attitude that early 20th-century painters adopted from him. What it ignores is our experience of apples and oranges. This contributes considerably to the sensuality of paintings like this.

Plate 45 *Mont Ste-Victoire.* 1904. 27 ½ × 35 ¼ in. (70 × 90 cm.). Philadelphia Museum of Art Pennsylvania, George W. Elkins Collection.
Cézanne's final manner achieved its fullest expression in the last landscapes of Mont Ste-Victoire and the Château Noir. The smaller units of thinly painted colour are now free agents, they act more individually than in the 80s (see plate 17). Their rectangular shape echoes the frame, their diagonal axes suggest receding orthogonals. The staccato line — sometimes coinciding with a colour plane, sometimes a free agent itself — strengthens the colour structure. The whole composition is animated by contrasts and unified by analogies. The subject was the landscape of his youth, full of emotional meaning for him. 'When one was born down there... nothing else means anything.' In these paintings a final union of his early romanticism and his mature discipline is achieved.

Plate 46 *The Large Bathers.* 1898-1906. 82 × 98¼ in. (208 × 249.5 cm.). Museum of Art, Philadelphia.
The most consciously architectural of the *Bathers* series, attempting to knit figures into landscape (see note to plate 37). But even here the vital synthetic vision of his mature landscape painting is embarassed by the presence of these grotesquely sub-Baroque women, forerunners of Picasso's *demoiselles*. What causes our discomfort — and Cézanne's presumably — in face of the distorted nude as opposed to the distorted landscape is firstly our offended self-recognition. The most hostile criticisms of Impressionist painting were after all against those paintings in which the figure was

submitted to their technique ('Do I look like that?' a critic demanded of Monet). A second relevant factor is the degree to which the European vision of the human body is conditioned by our traditional ideal of Classical art. The adjective 'Gothic' applied by so many writers to this painting probably stems more from this expressive anti-ideal quality than from the pointed vaults overhead.

Plate 47 *Les Grandes Baigneuses.* 1898-1906. 50⅛ × 77⅛ in. (127 × 195 cm.). National Gallery, London.
See note to Plate 46. This is one of the most fluidly painted of the big late Bathers compositions. Cézanne's treatment of the figure is as free and uninhibited as in the romantic figure paintings of the 1860s which the *Bathers* inevitably recall.

Plate 48 *The Gardener. c.* 1906. 25 ¾ × 21 ⅝ in. (65.5 × 55 cm.). Tate Gallery, London.
One of at least six studies of Cézanne's odd job man Vallier. Three of these were watercolours and the technique of this unfinished oil has an appearance of watercolour in its soft colours and thin merging paint. The rippling fluidity of the drawing here is also a feature of the late watercolours (see figure 5).

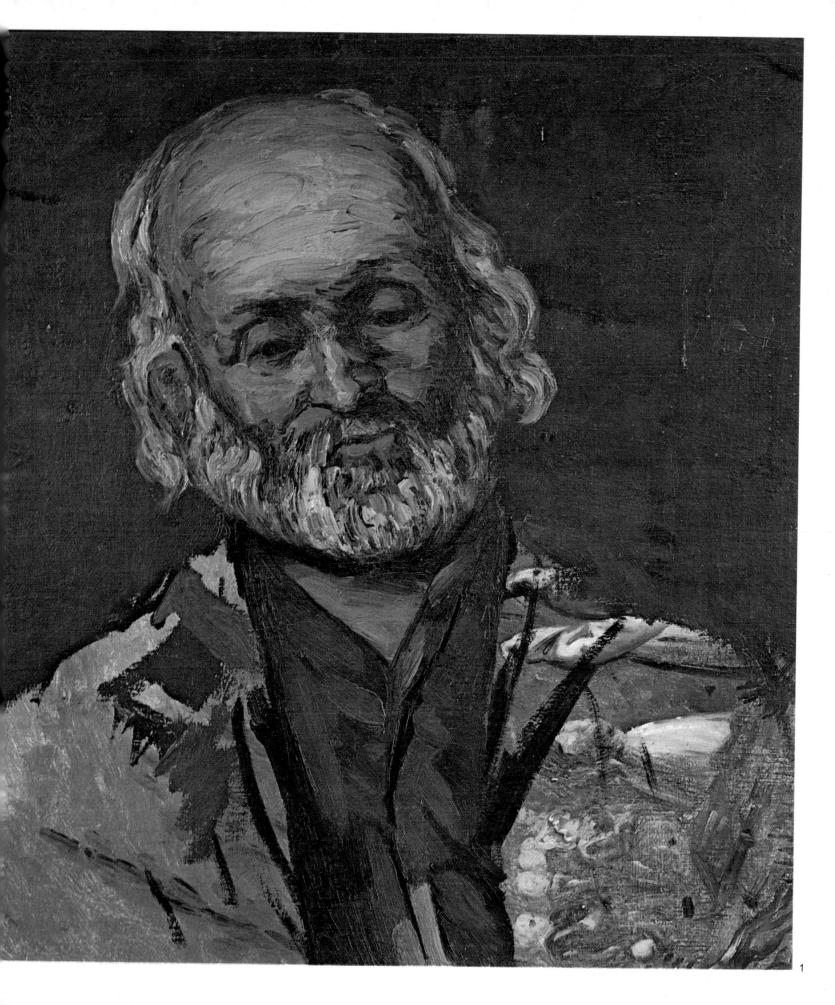

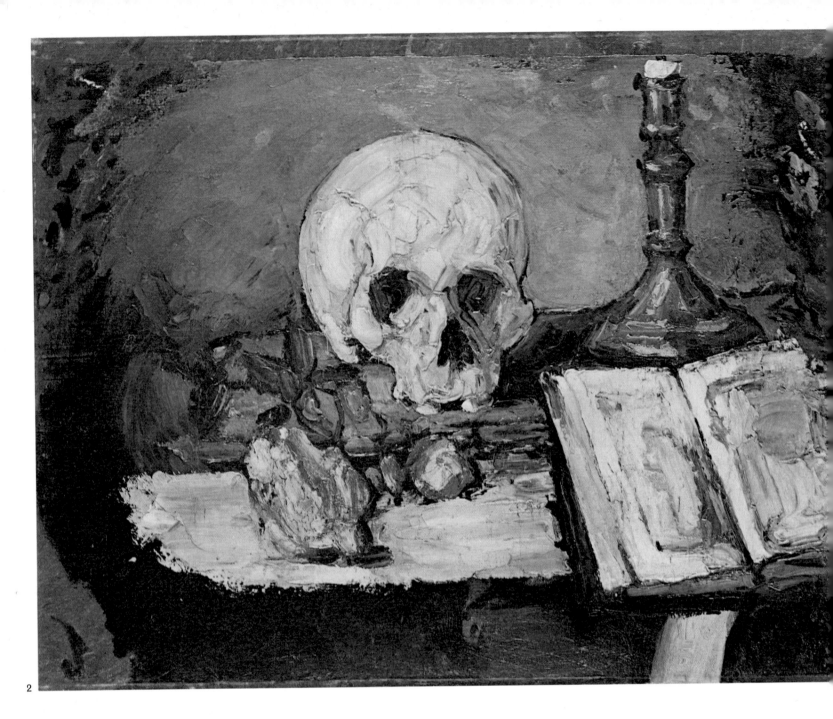

2

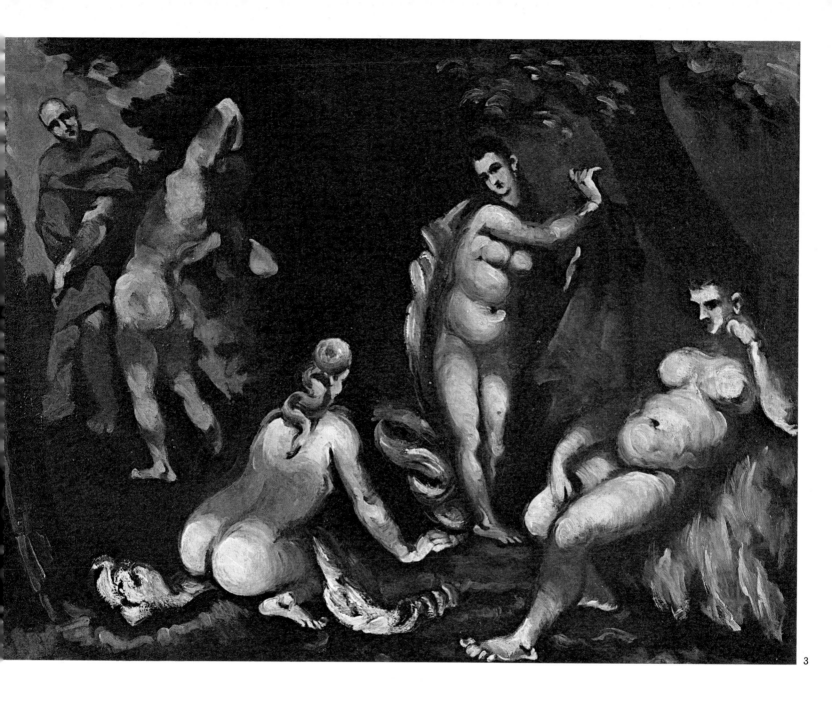

3

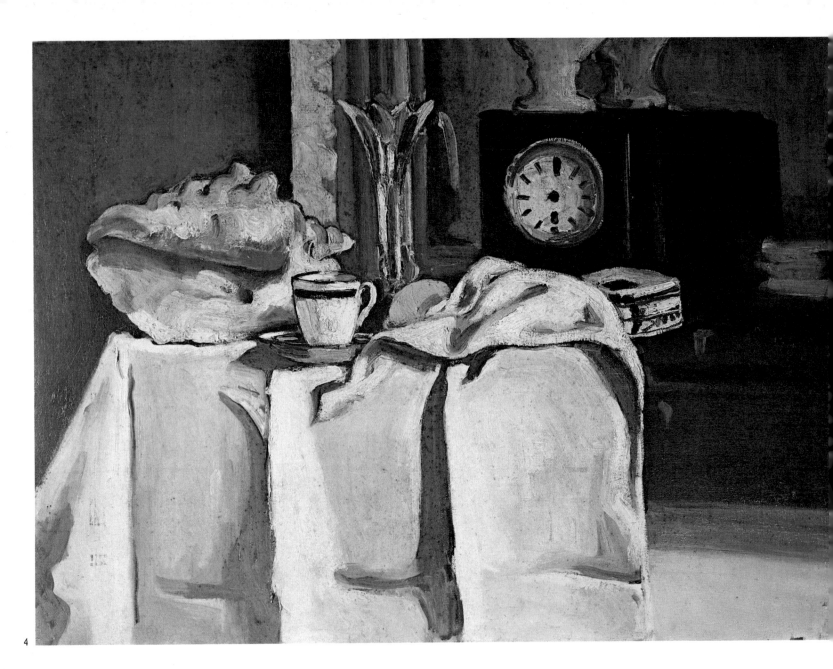

4

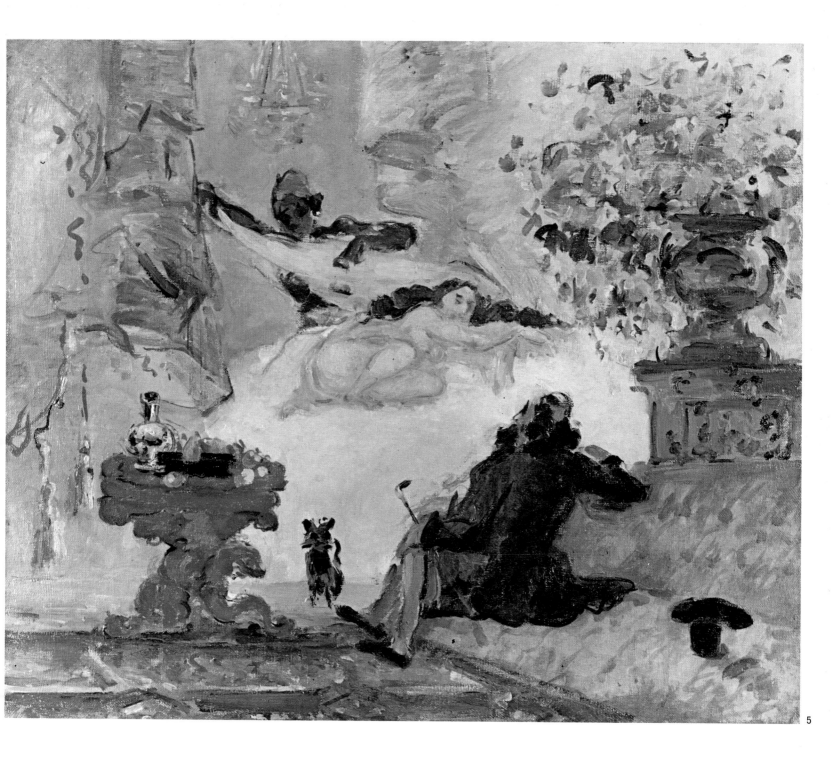

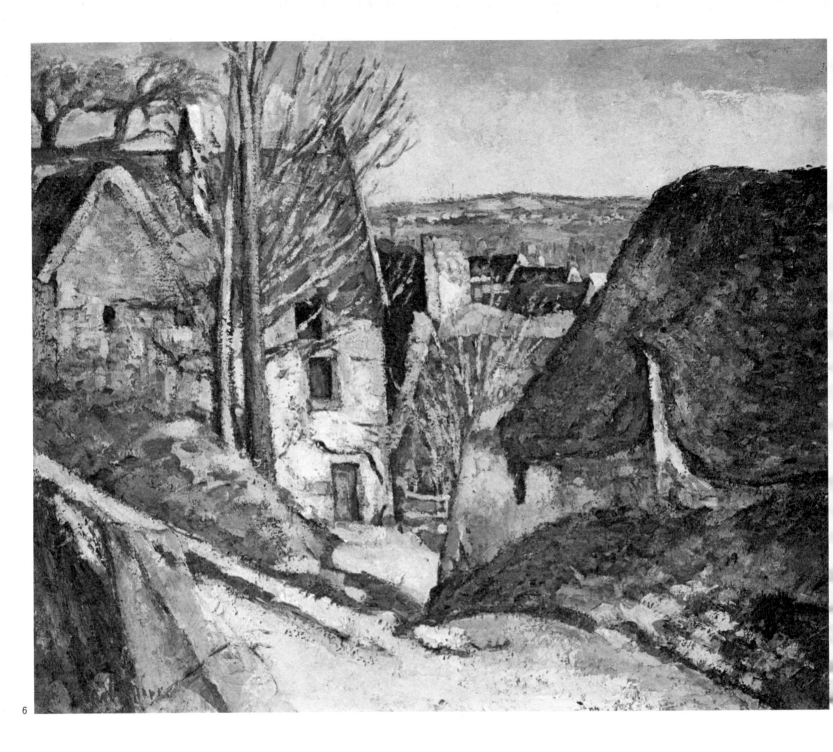

6

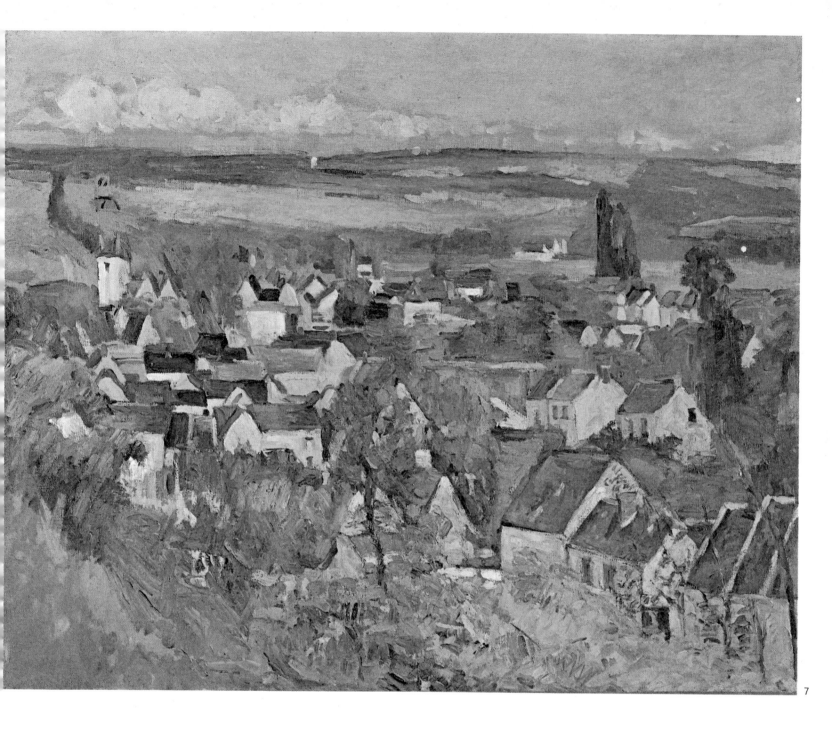

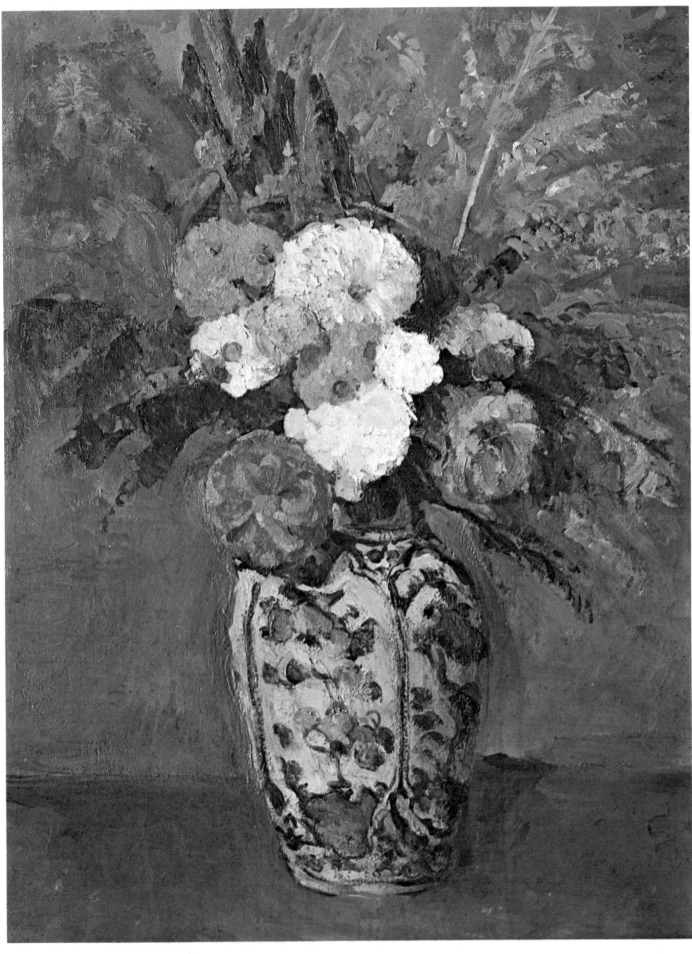

8

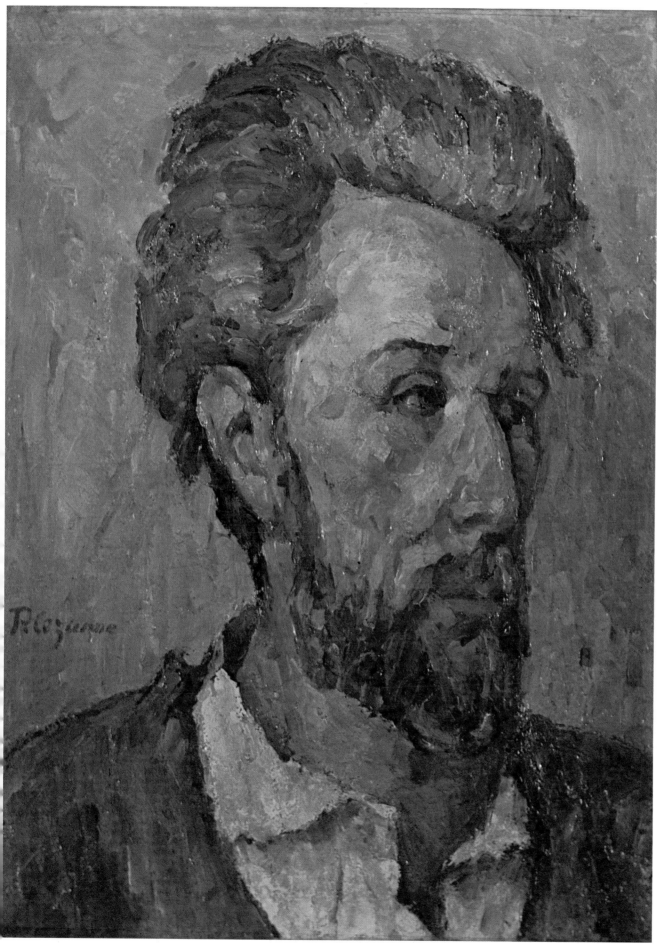

9

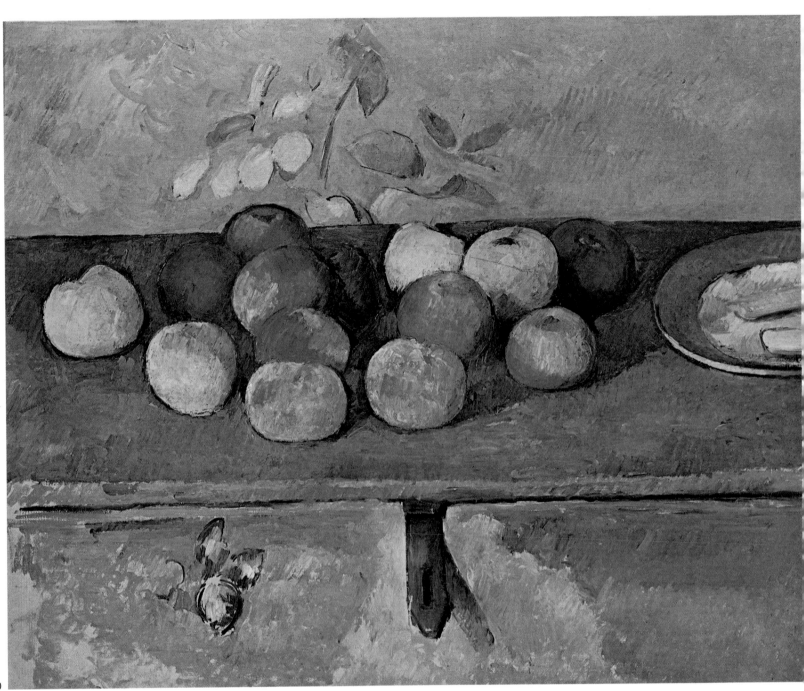

10

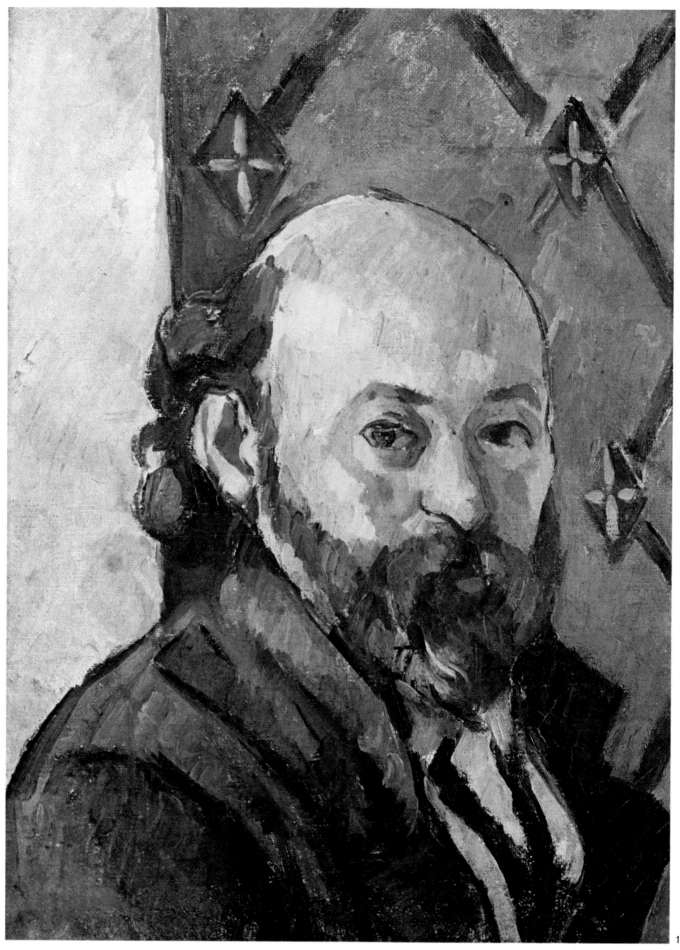

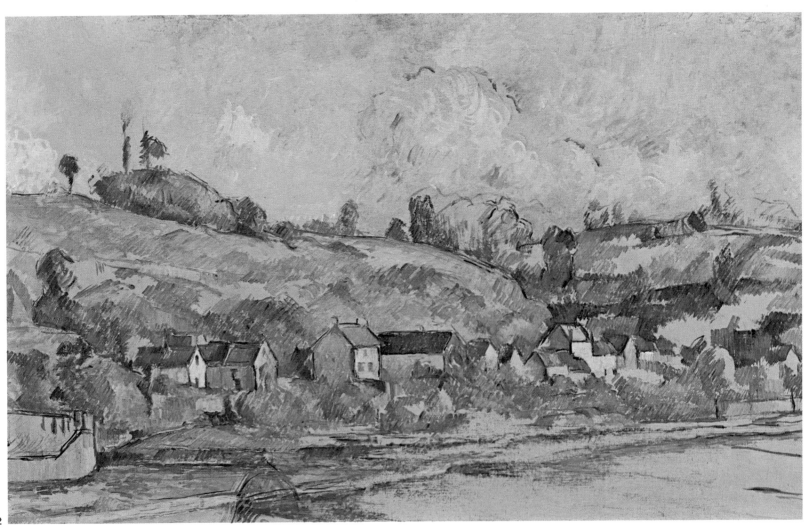

12

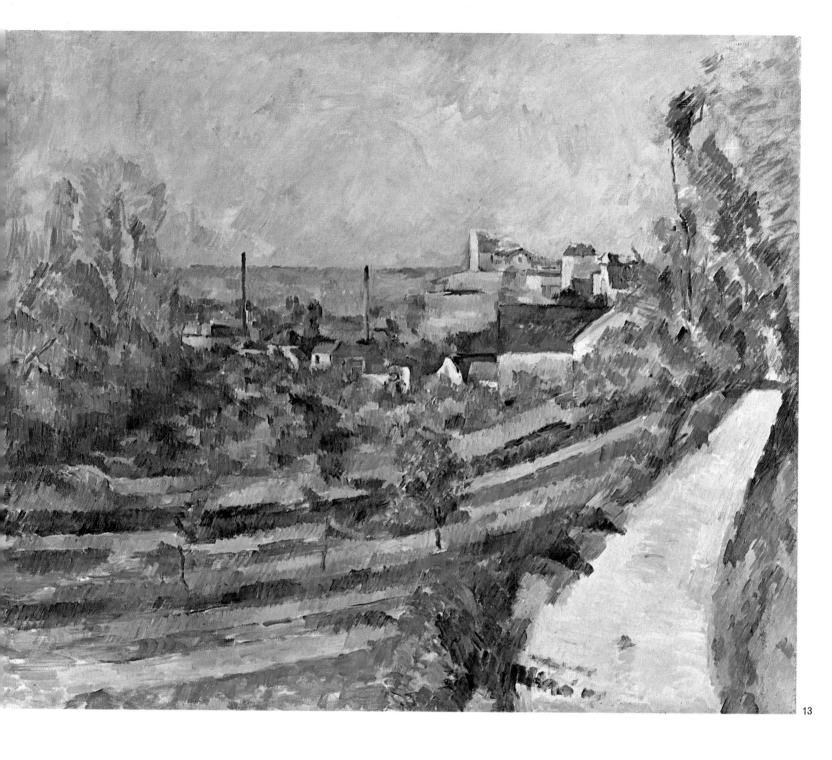

13

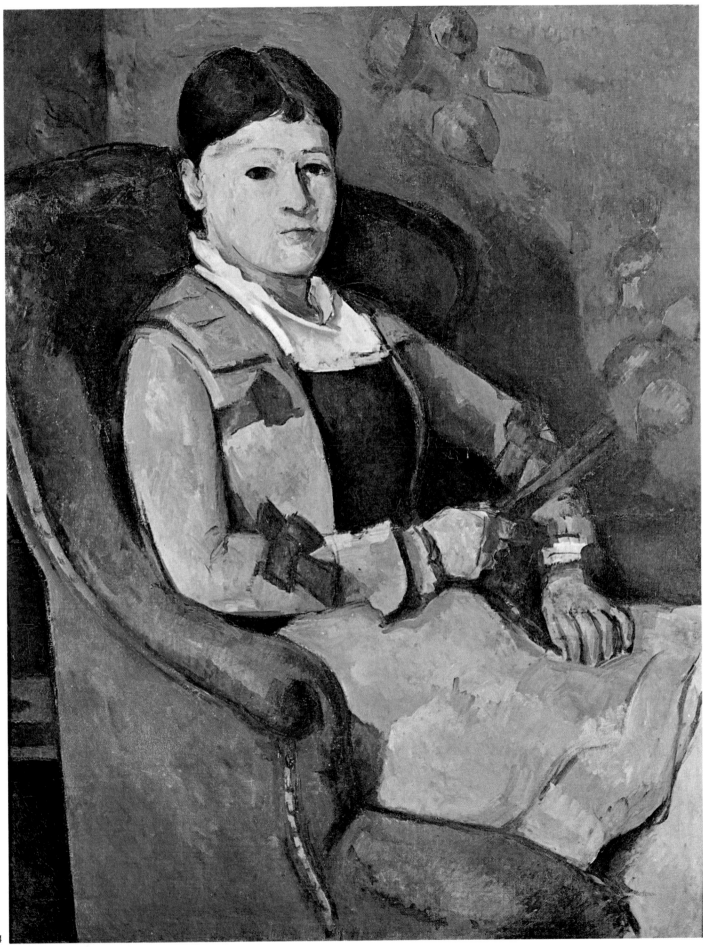

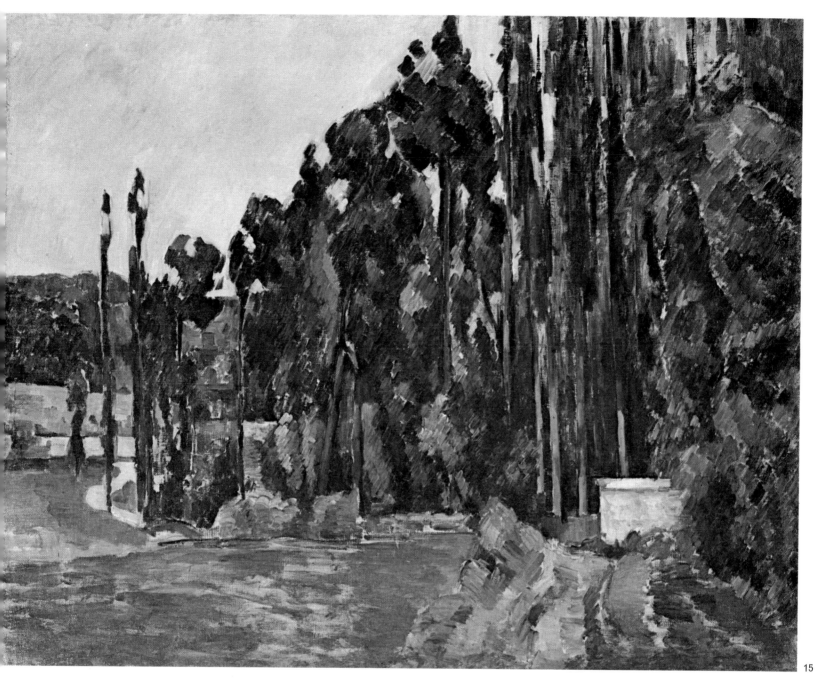

15

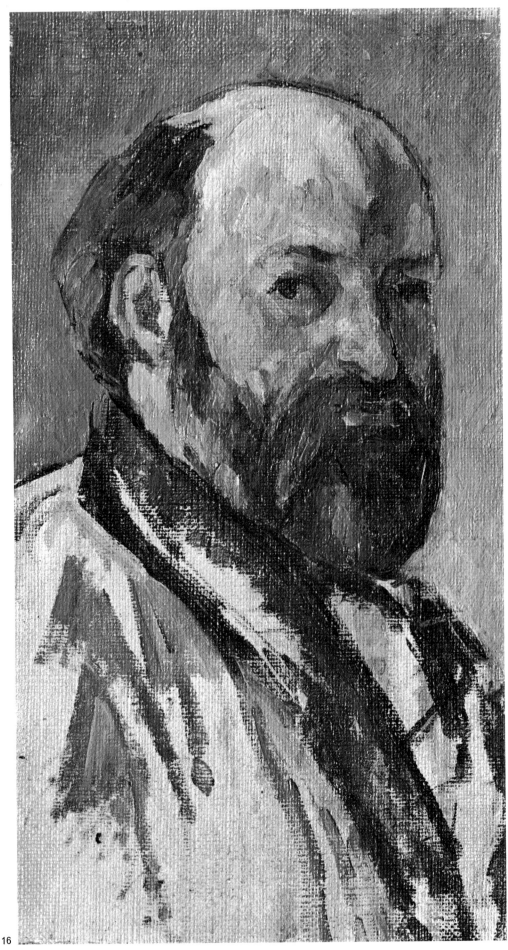

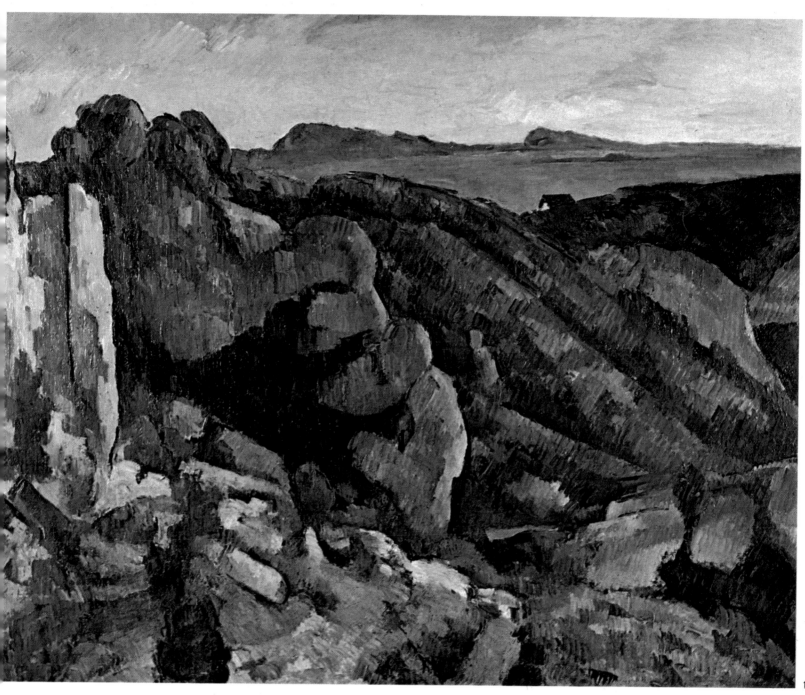

17

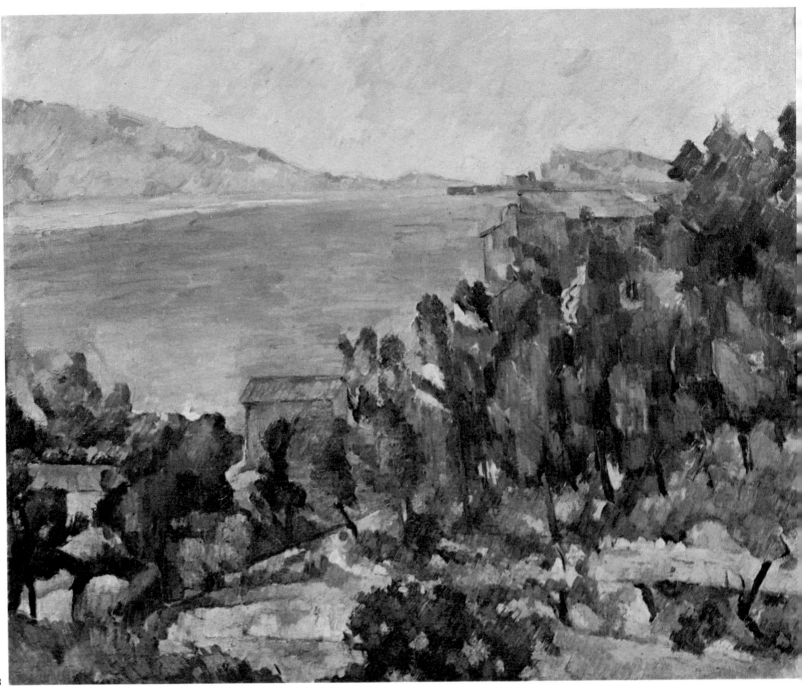

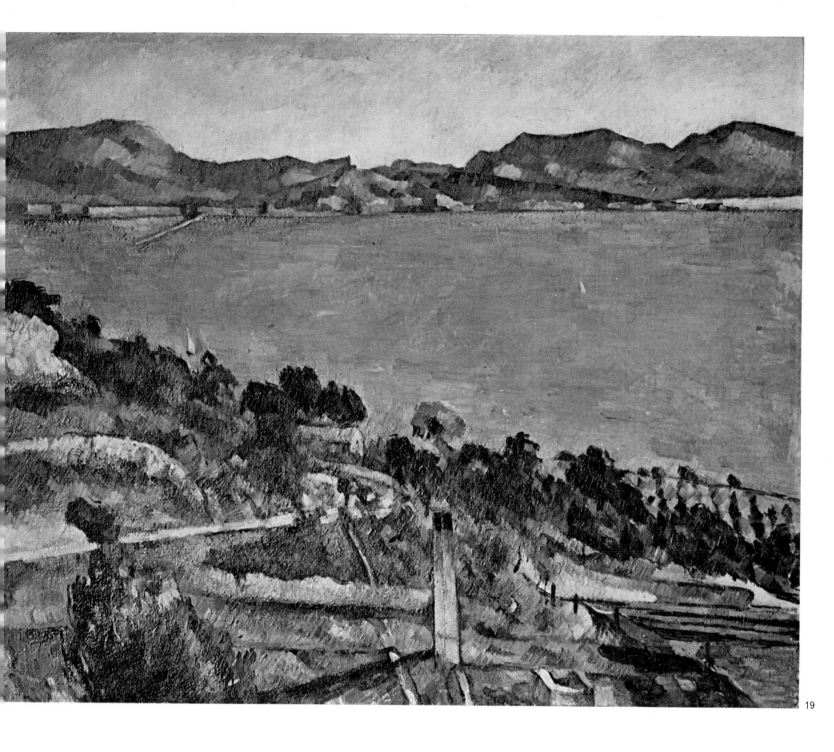

19

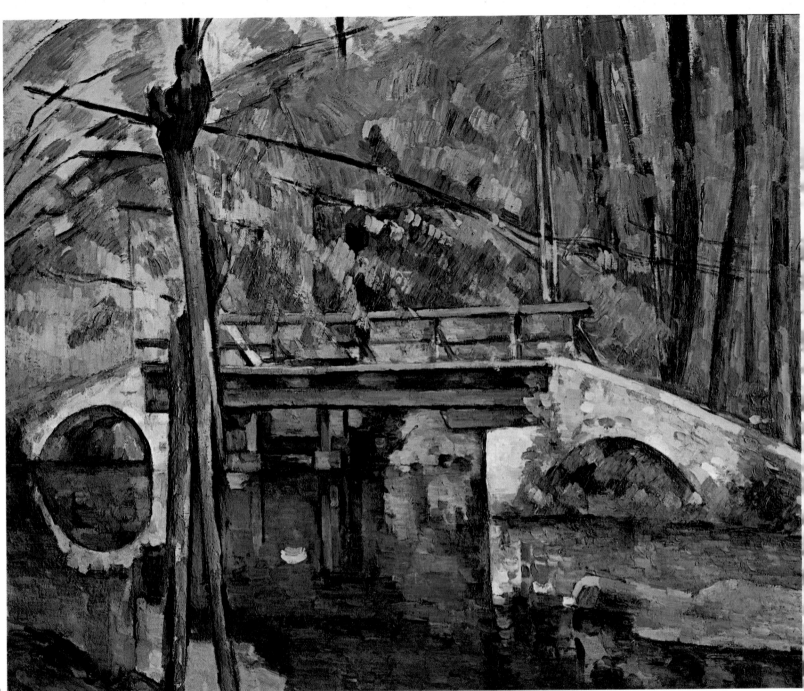

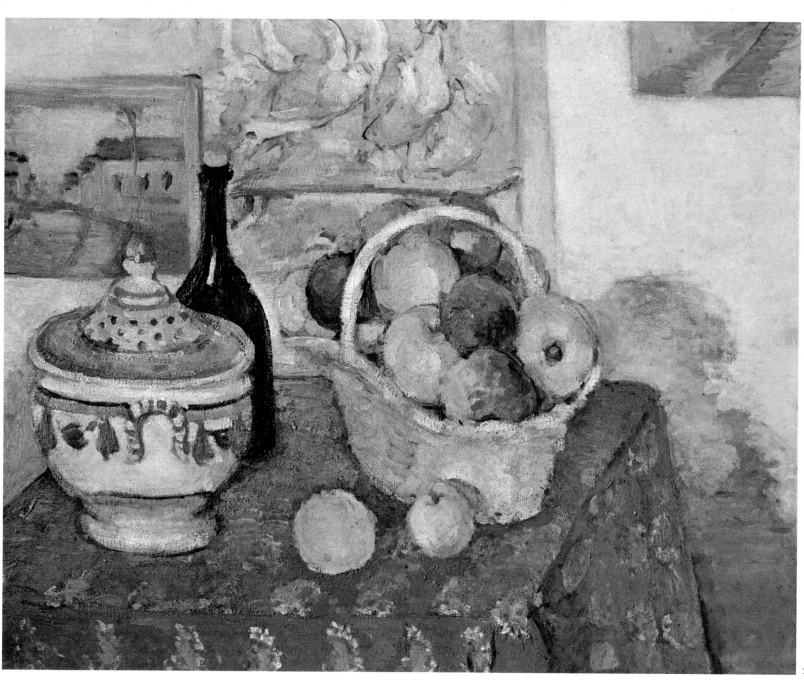

21

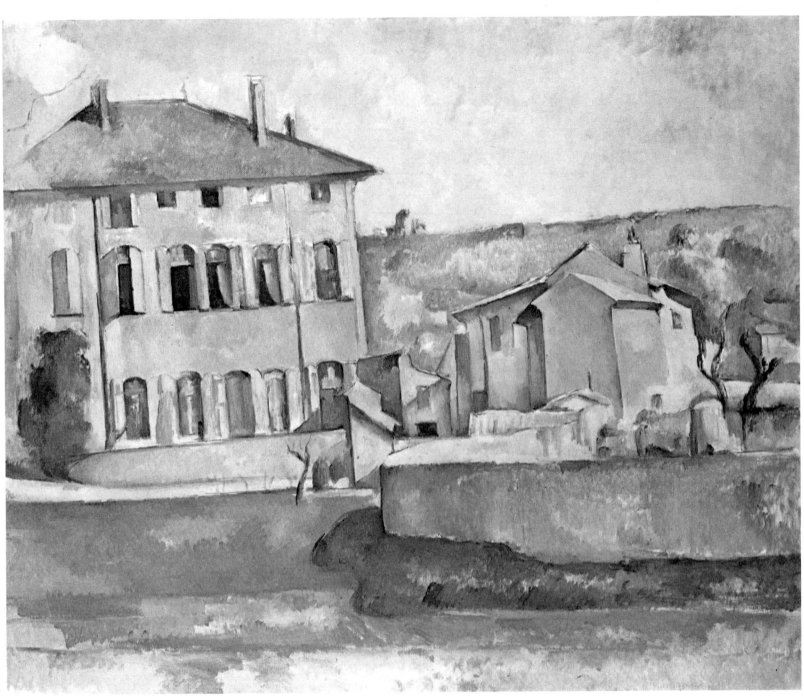

22

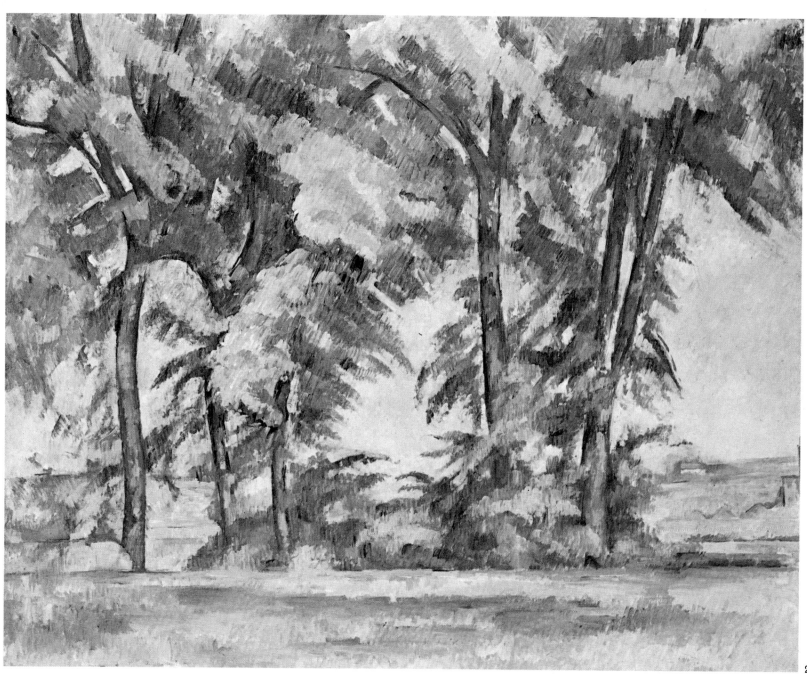

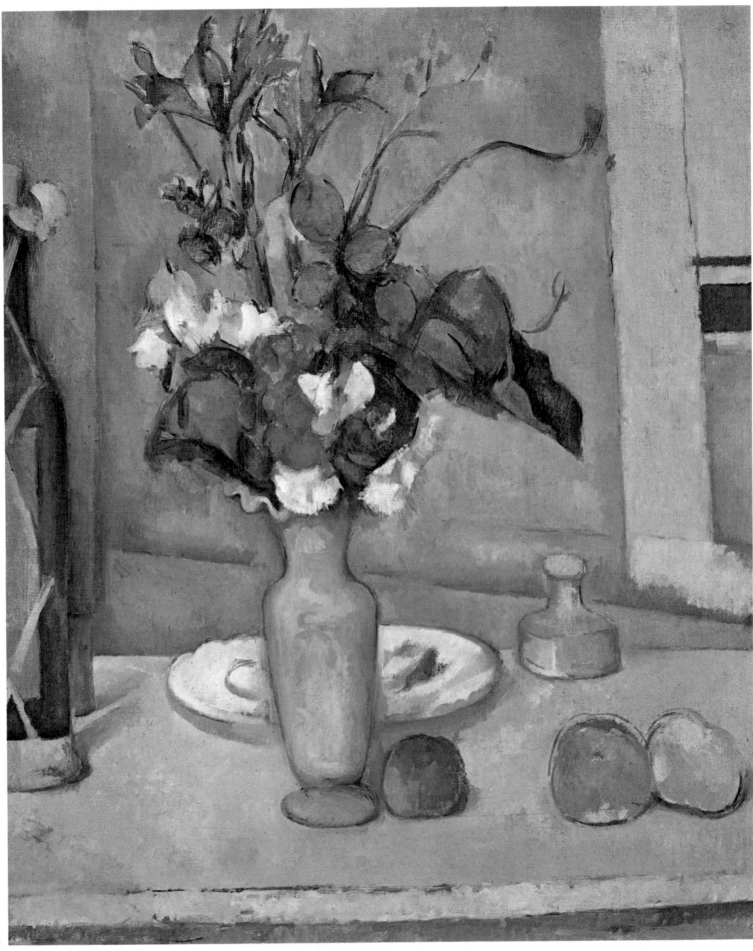

24

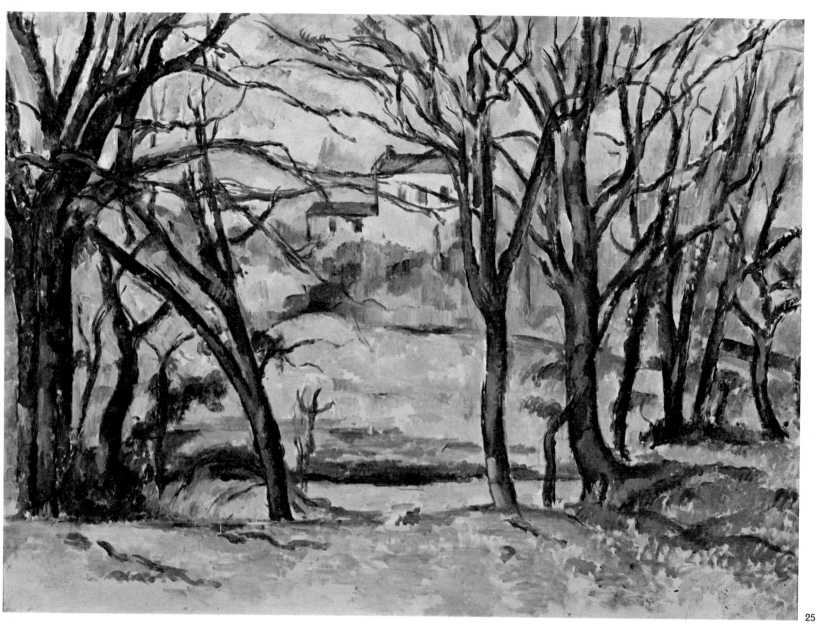

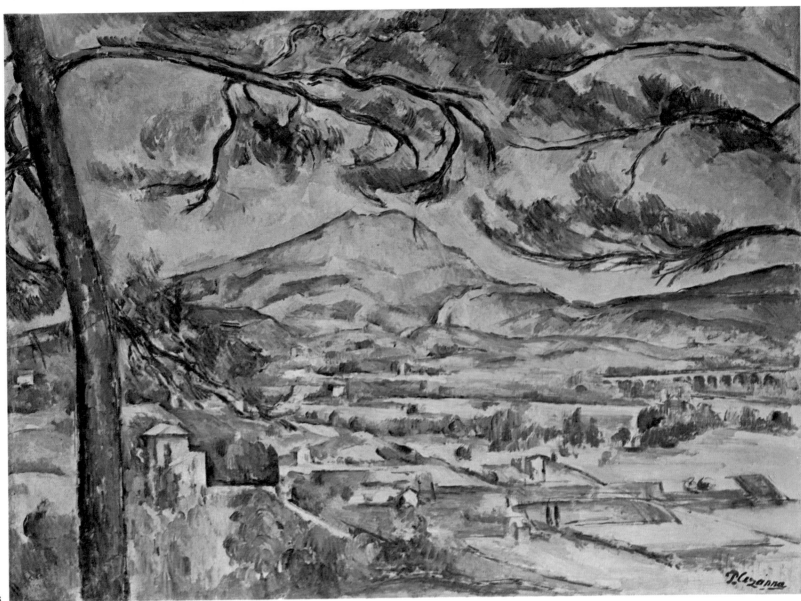

26

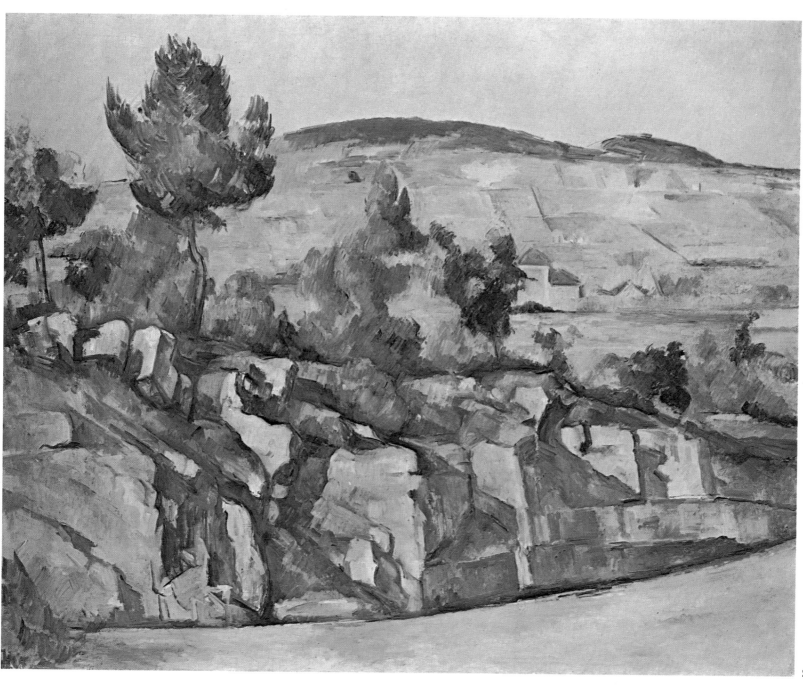

27

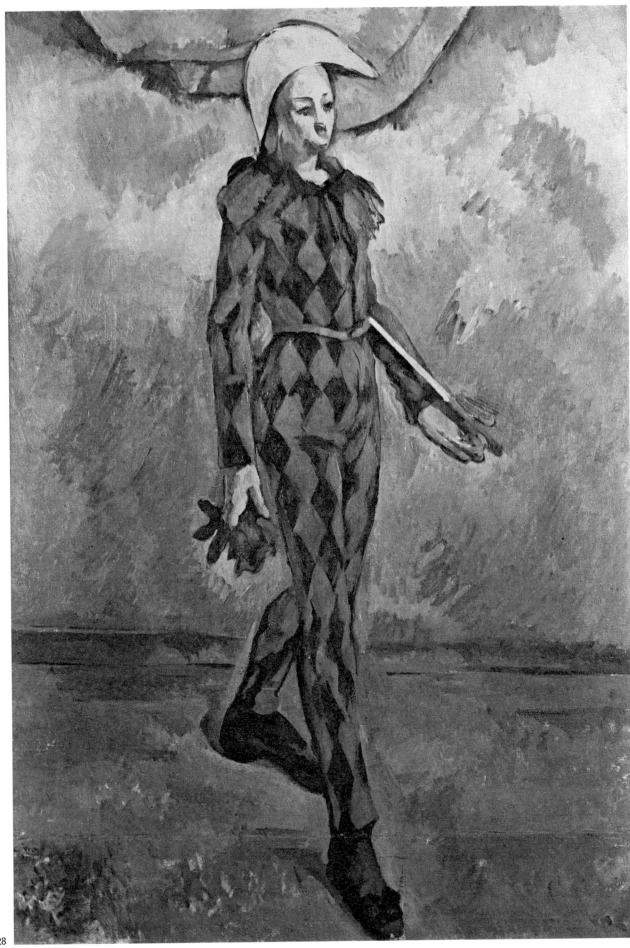

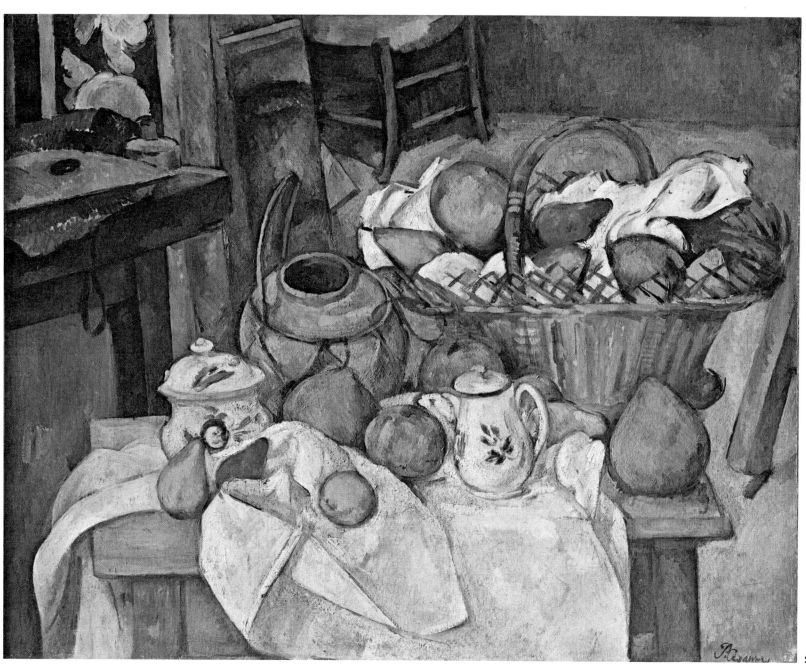

29

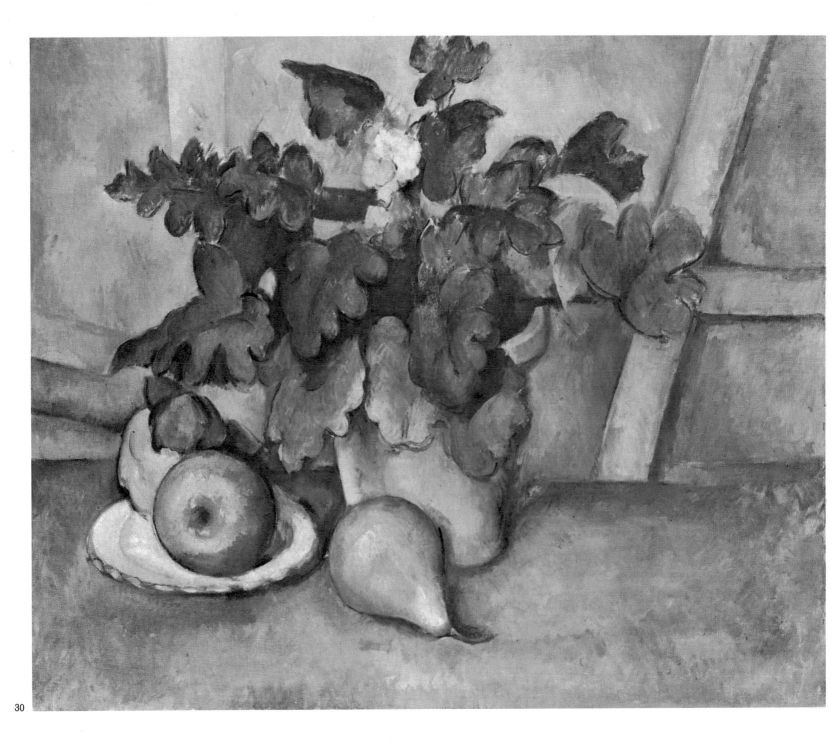

30

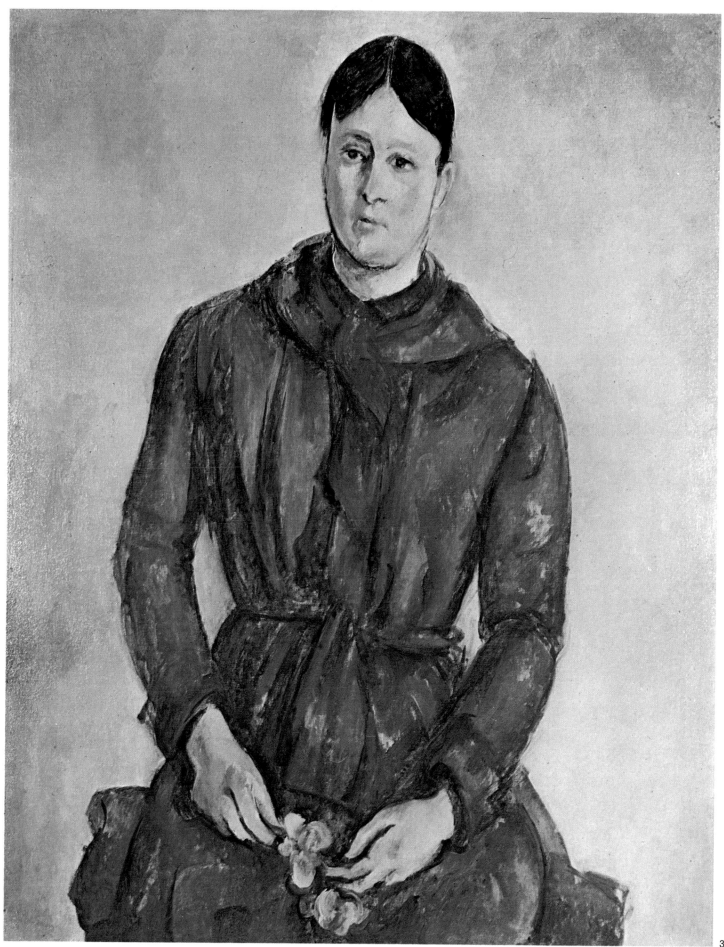

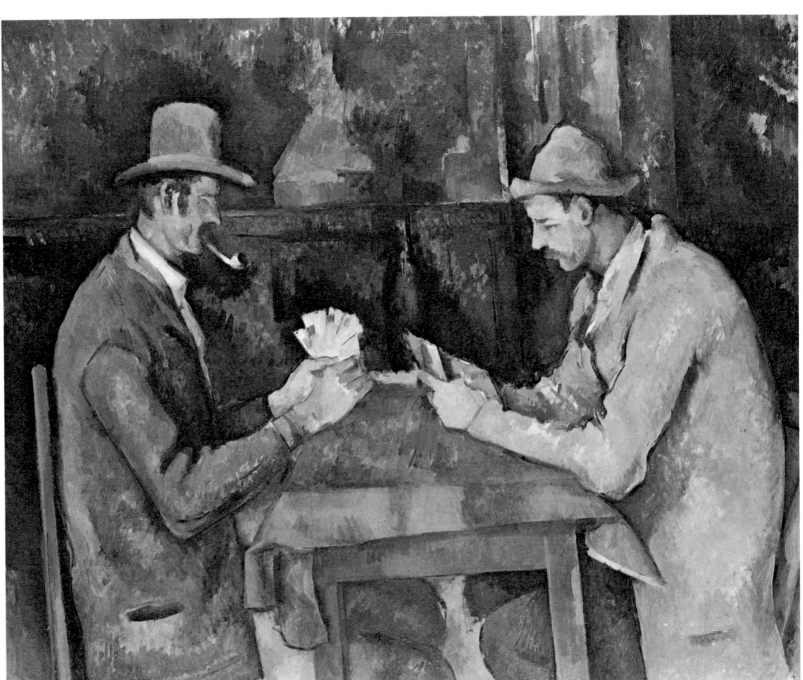

32

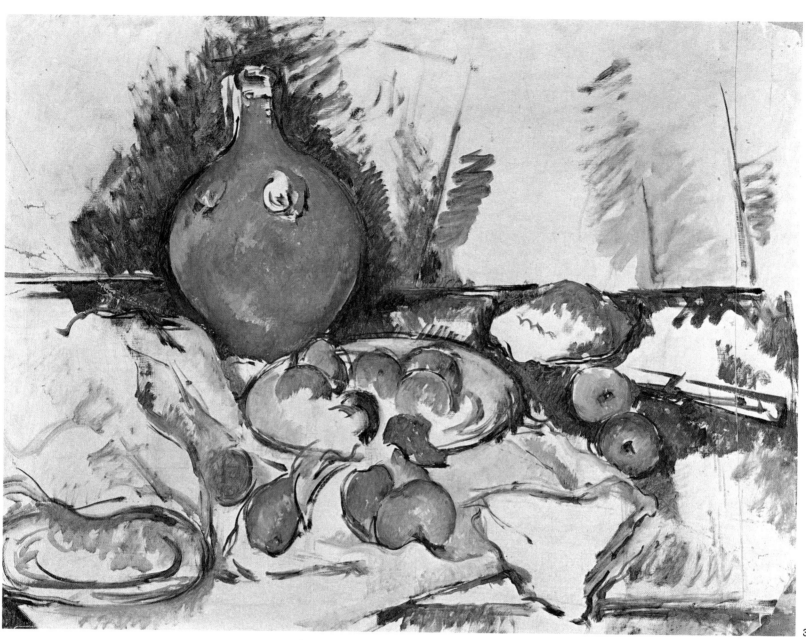

33

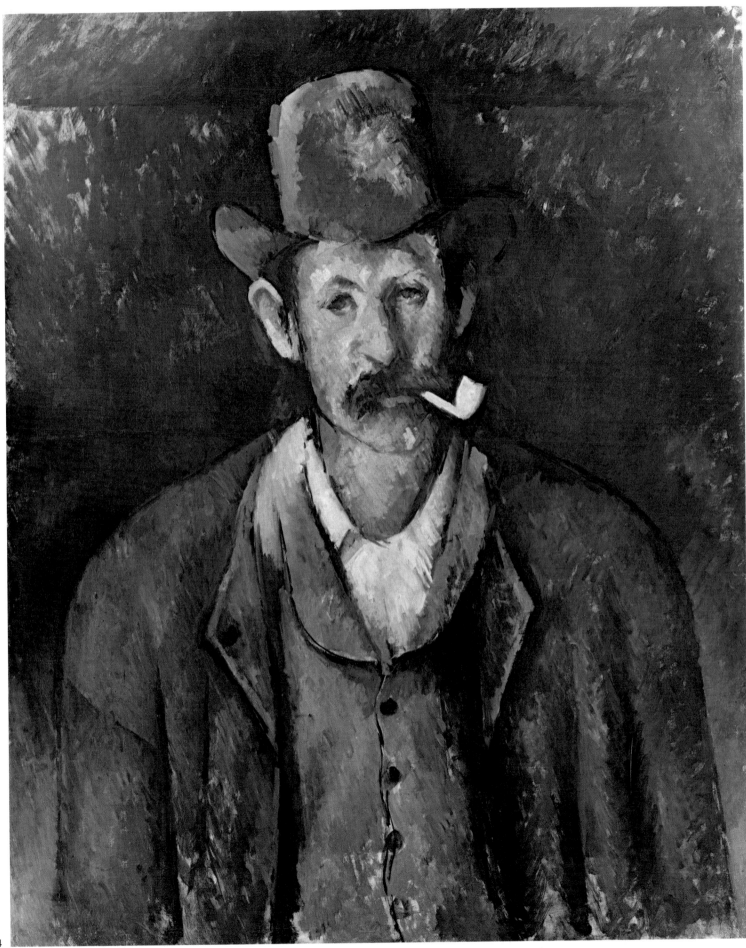

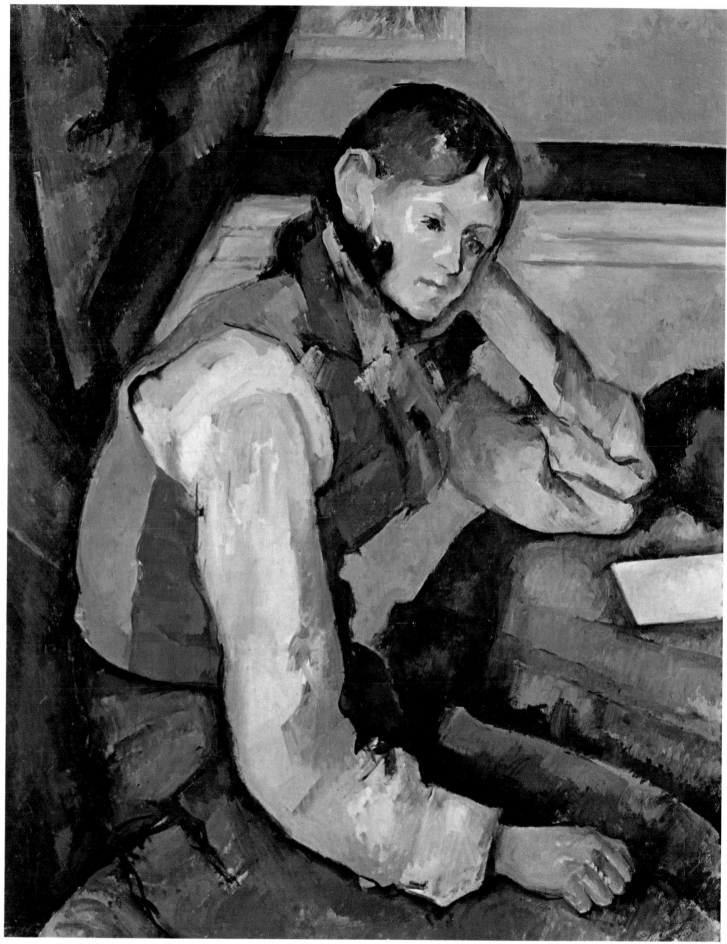

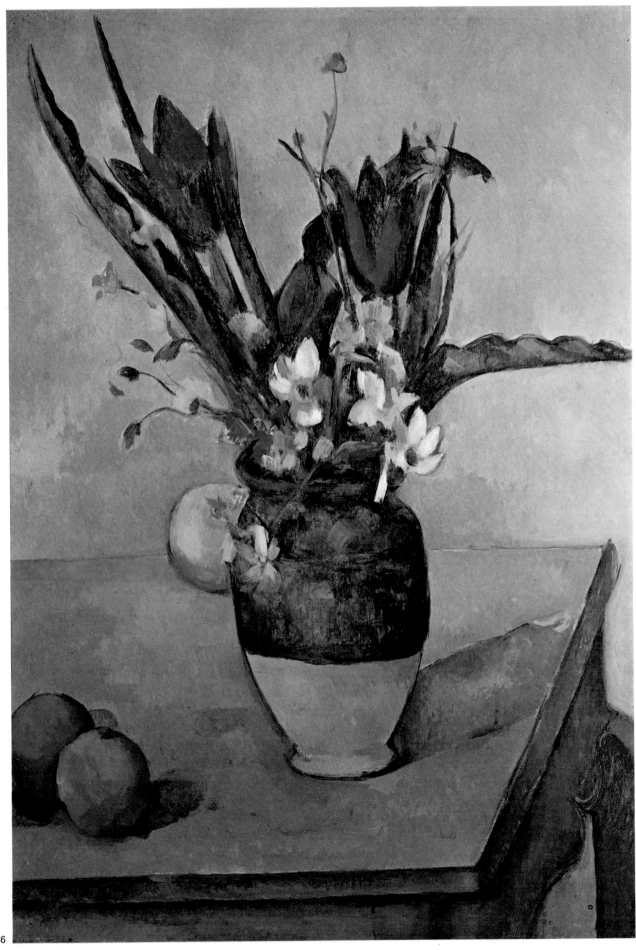

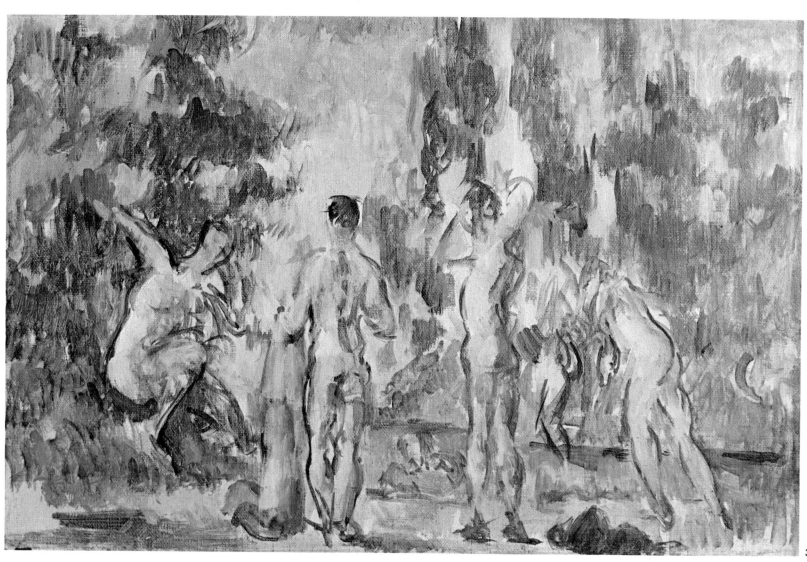

37

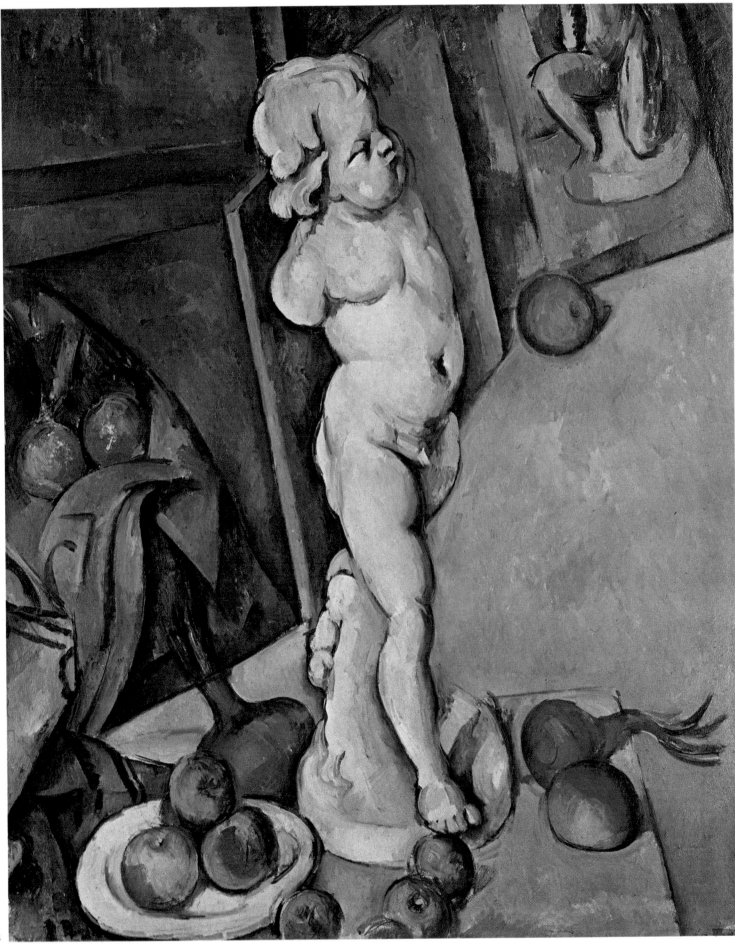

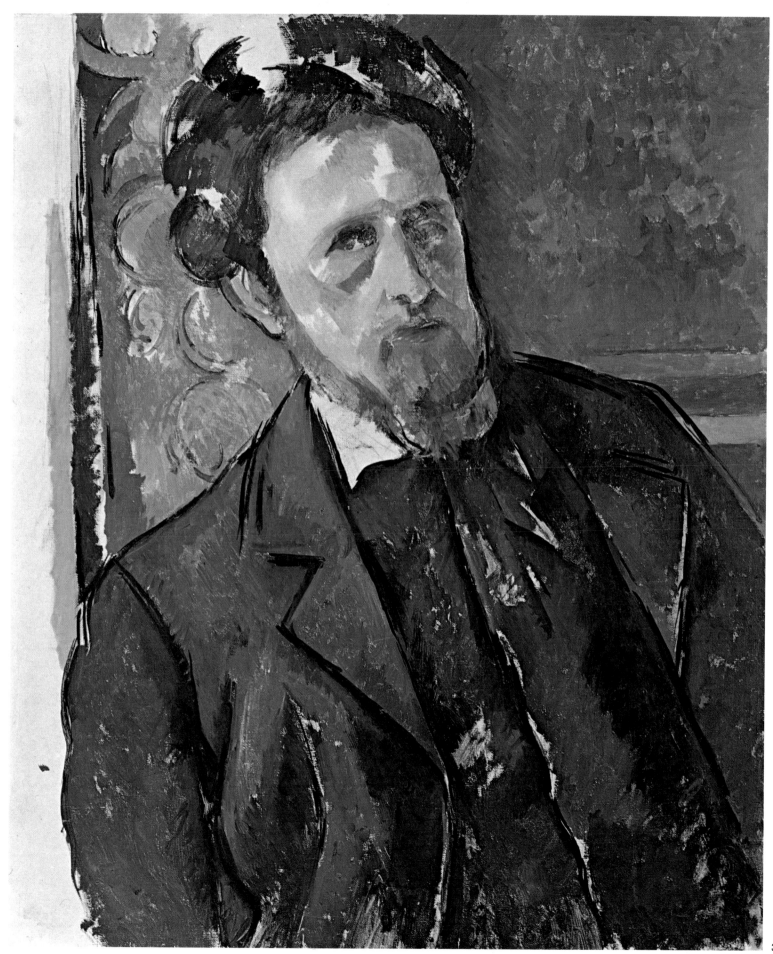

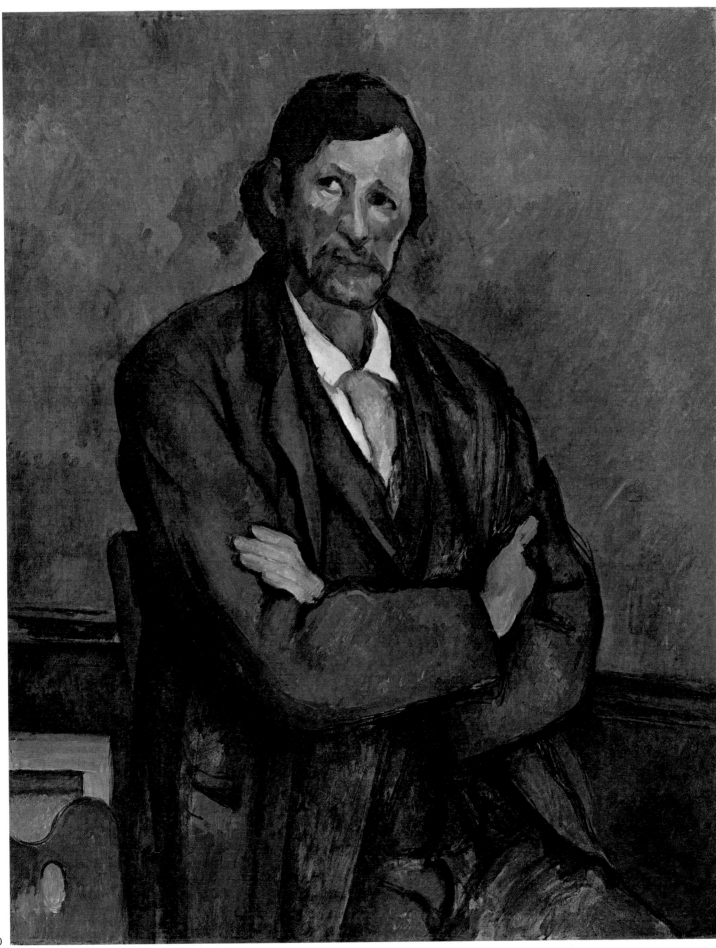

40

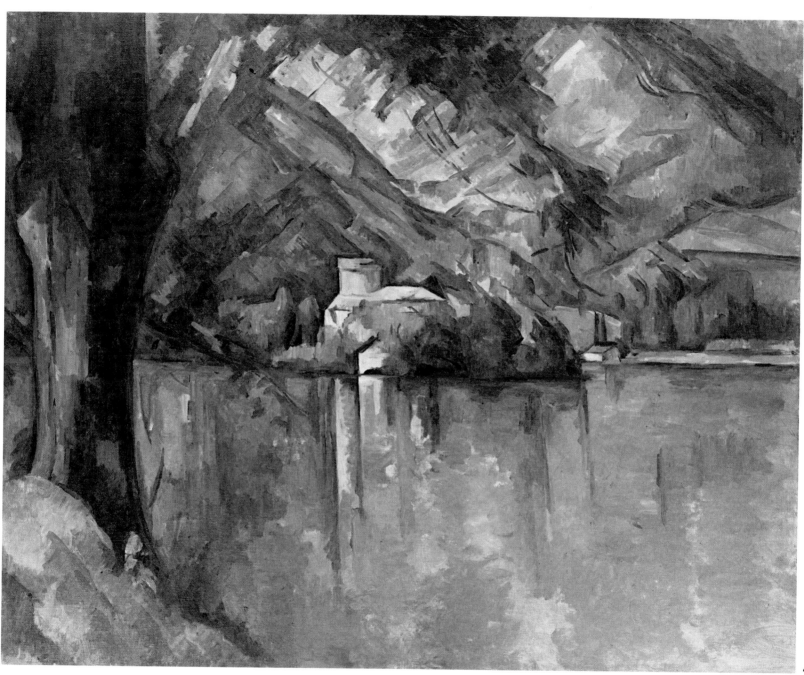

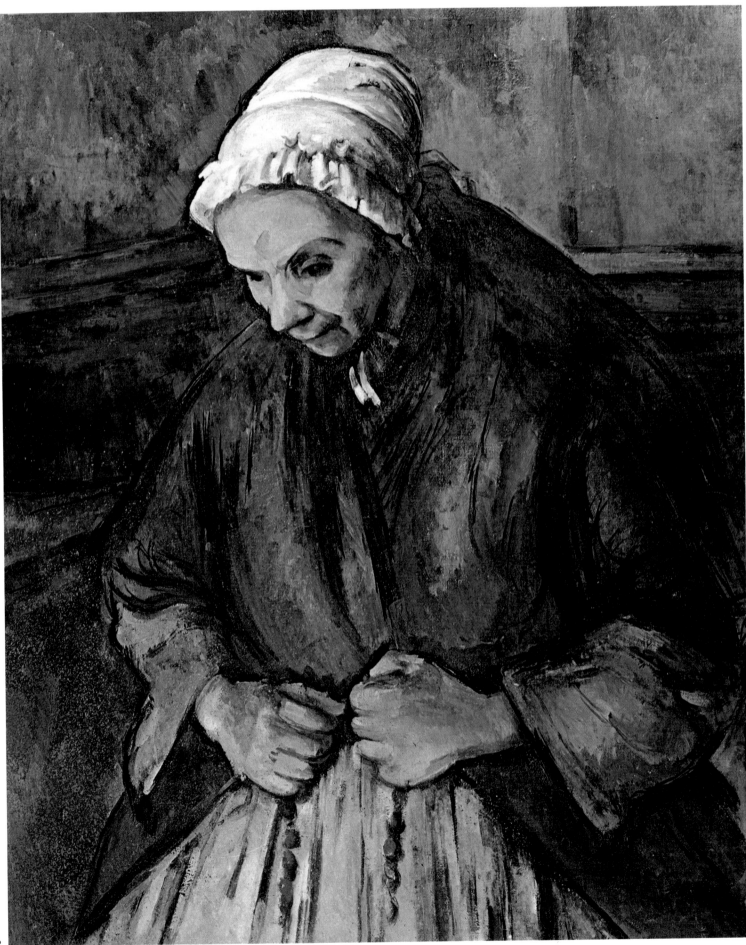

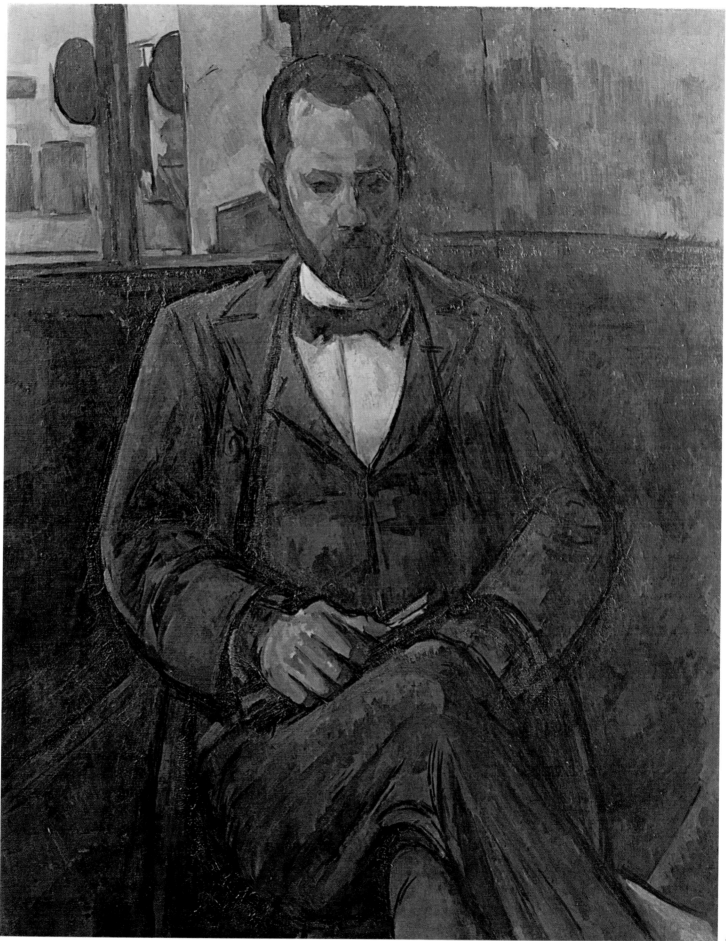

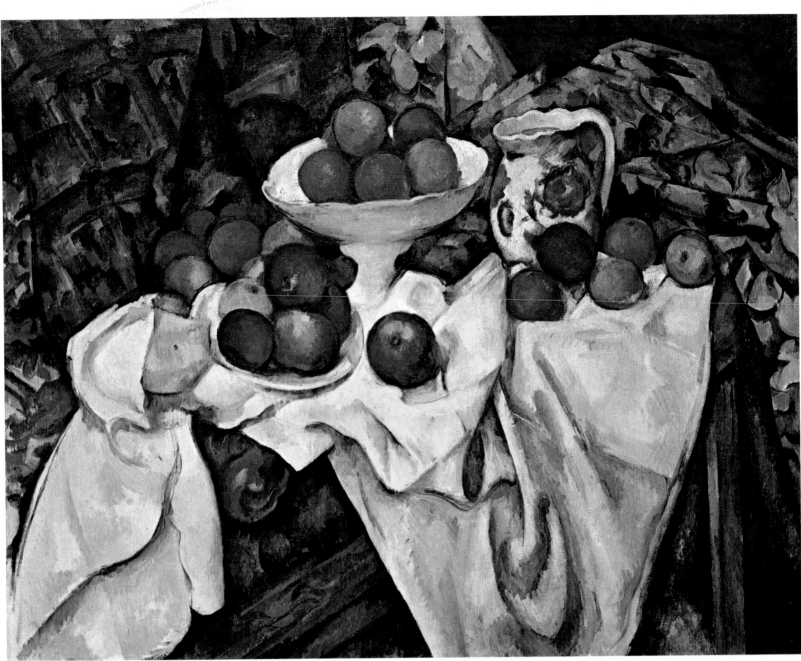

44

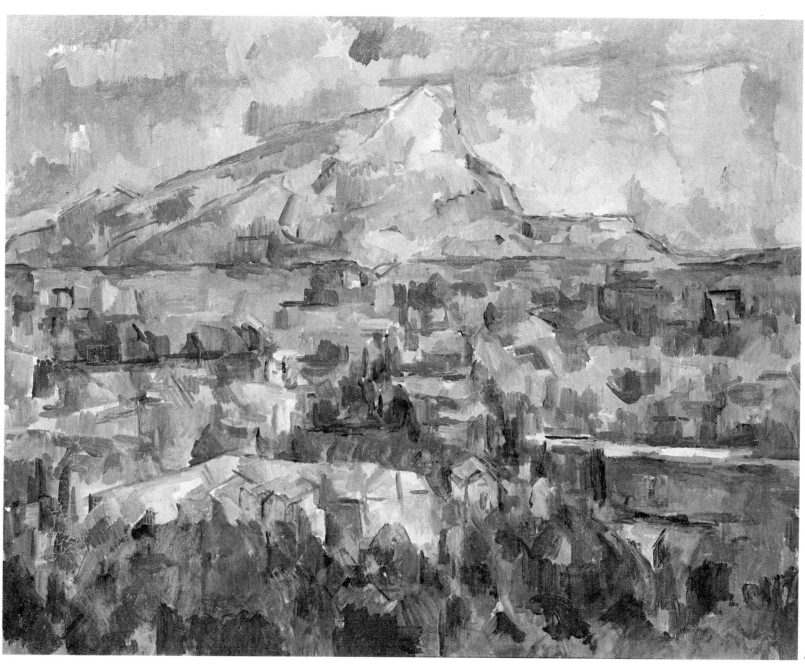

45

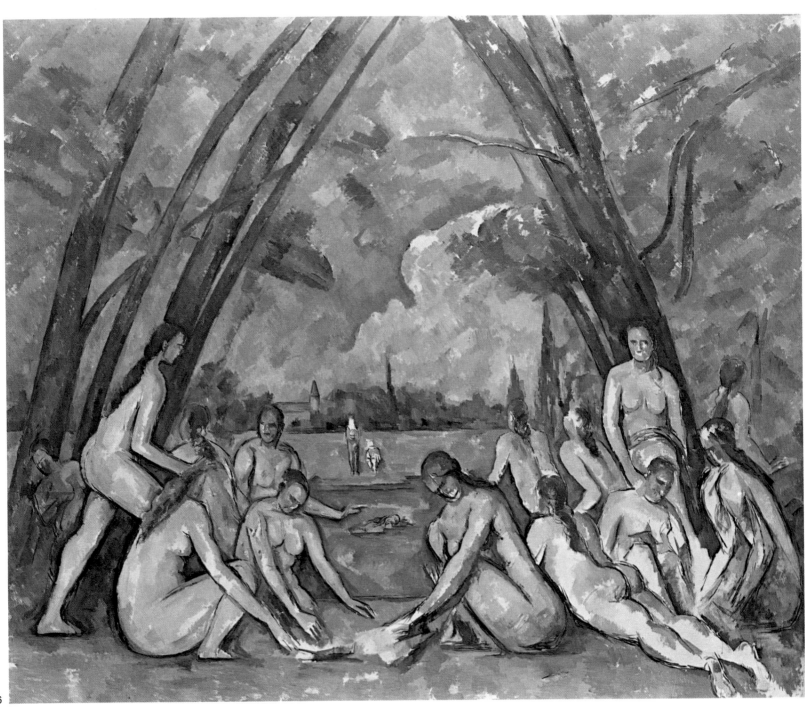

46

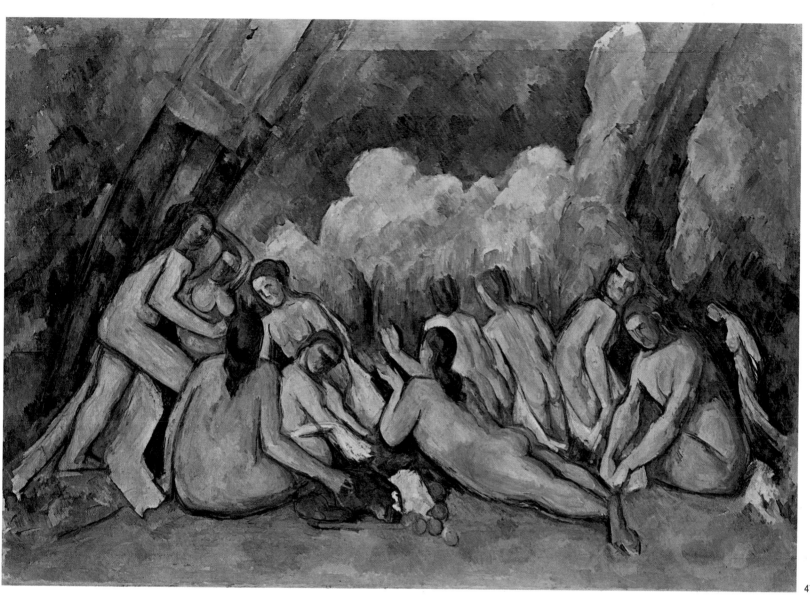

47